Unit 1 Looking Around
Seeing Our World

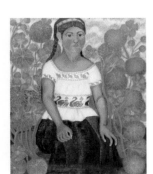

Unit 3 Colorful Stories
Color and Imagination

page

Unit 4 Art and Nature
Getting Ideas

Unit 5 Special Times
Art to Remember

Unit 6 Change
New and Different

Student Handbook	page

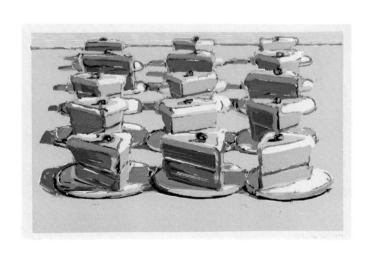

What is art?
Art is . . .

Photography

Painting

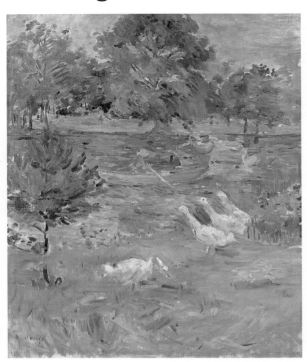

Berthe Morisot, *Girl in a Boat with Geese,* ca. 1889.

Sculpture

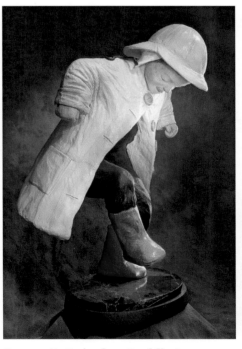

Susan J. Geissler, *Puddle Jumper,* 2005.

Architecture

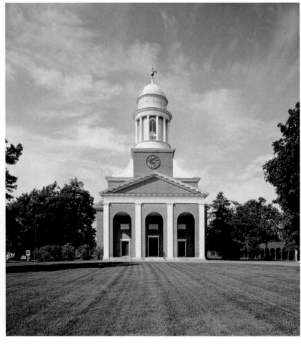

Charles Bulfinch, Church of Christ, 1816.

Clothing

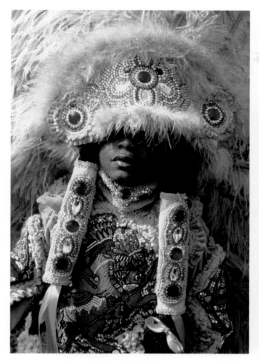

Young Mardi Gras Indian, New Orleans, Louisiana.

Weaving

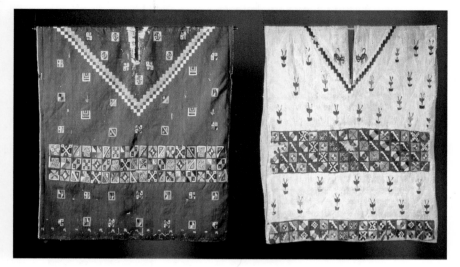

Two Inca Ponchos with Geometric Designs, ca. 1380–1520.

Furniture

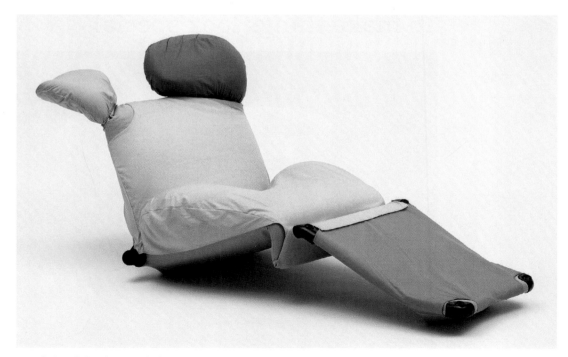

Toshiyuki Kita, *Wink Lounge Chair*, 1980.

People make art. Why?

To tell stories.

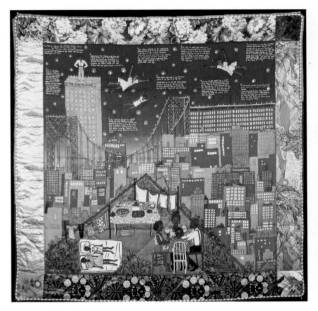

Faith Ringgold, *Tar Beach 2*, 1990.

To share feelings.

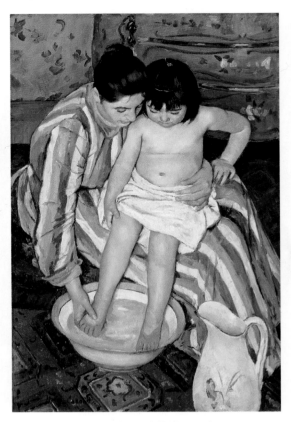

Mary Cassatt, *The Child's Bath*, 1893.

To make things look special.

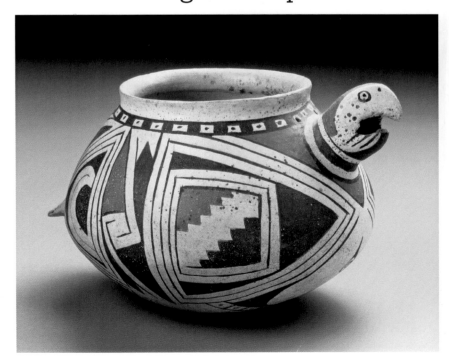

Macaw Bowl, 1300–1350.

To remember special people.

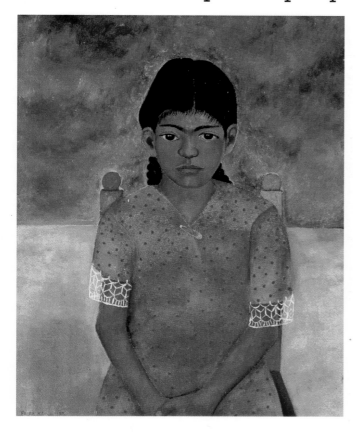

Frida Kahlo, *Portrait of Virginia,* 1929.

To remember special times.

Doris Lee, *Thanksgiving,*
ca. 1935.

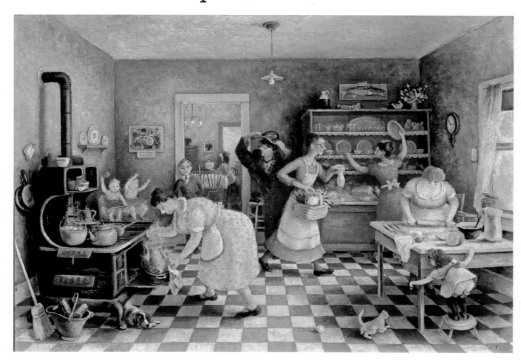

People make art everywhere in the world.

Mexico

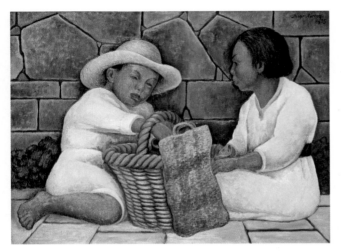

Diego Rivera, *Children at Lunch*, 1935.

Italy

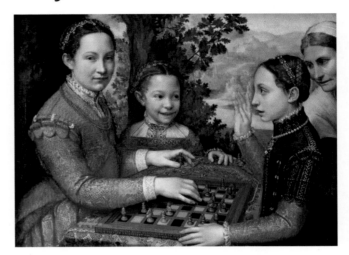

Sofonisba Anguissola, *A Game of Chess*, 1555.

Niger

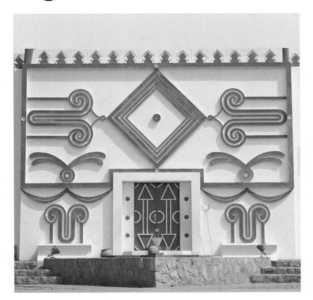

Pavilion at National Museum. Niamey.

India

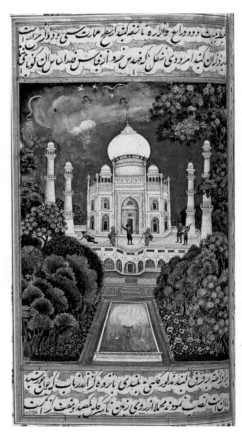

The Taj Mahal at Agra, 1600s.

Egypt

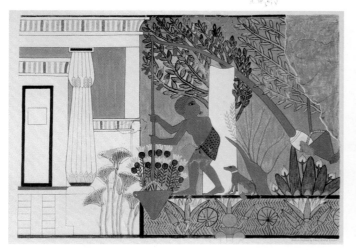

The Watering of Plants in a Garden, 1300–1200 BCE.

Canada

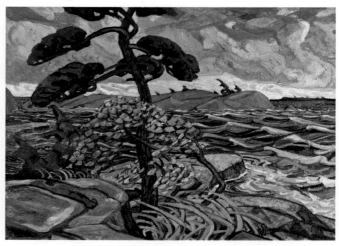

Arthur Lismer, A September Gale, Georgian Bay, 1920.

China

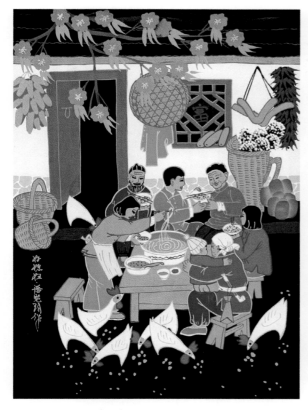

Tempera painting.

Spain

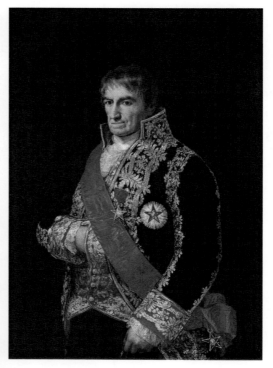

Francisco Goya, *Portrait of General José Manuel Romero, 1810.*

People who make art are called artists. Artists choose their subjects.

Portrait

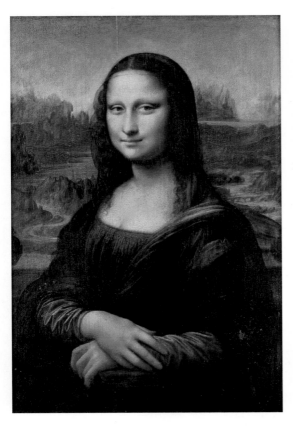

Leonardo da Vinci, *Mona Lisa (La Gioconda)*, 1503–1506.

Still life

Tom Wesselmann, *Still Life #30*.

Landscape

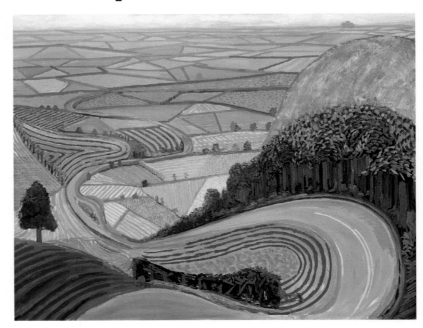

David Hockney, *Garrowby Hill*, 1998.

Artists choose their materials.

Paint

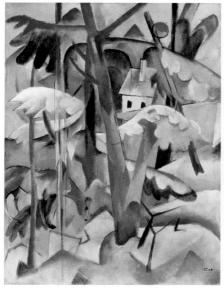

Heinrich Campendonk, *Landscape,* 1917.

Stone

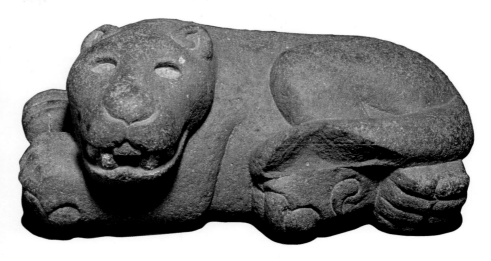

Aztec, *Reclining Jaguar,* 1440–1521.

Artists think about their composition.

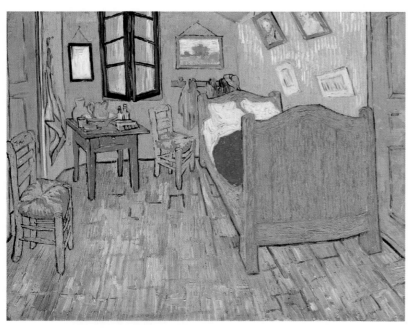

Vincent van Gogh, *The Bedroom,* 1889.

What do you see in this painting?

Art is a language. The elements of art are the words of the language.

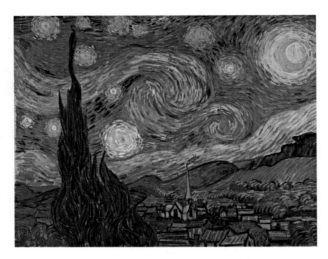

Vincent van Gogh, *The Starry Night*, 1889.

Color

Line

Shape

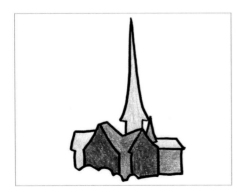

Form

Texture

Value

Artists organize these words using the principles of design.

Pattern

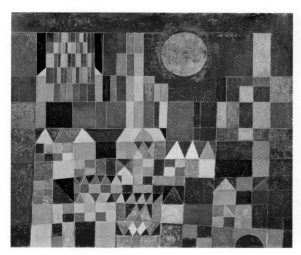

Paul Klee, *Castle and Sun*, 1928.

Movement and Rhythm

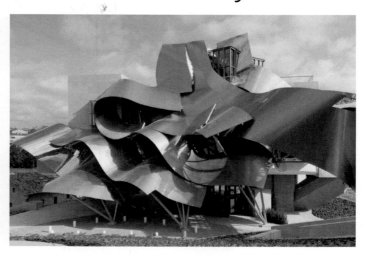

Frank Gehry, Hotel Marques de Riscal Elciego, 2006.

Variety and Unity

Balance

Art Criticism

Loïs Mailou Jones,
*Coin de la Rue
Medard*, 1947.

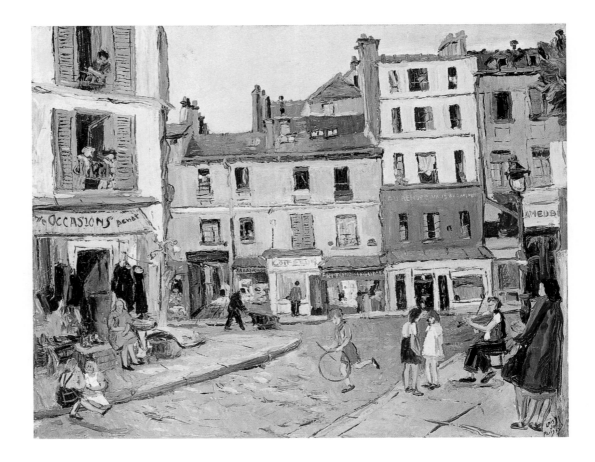

1. We **describe** what we see.
 What do you see in this painting?

2. We **analyze** the painting's organization.
 What details did the artist paint?

3. We **interpret** what the artwork is saying.
 How do you think the artist feels about
 this place?

4. We **evaluate** the artwork.
 What do you like about this artwork?

A 5-Step Process

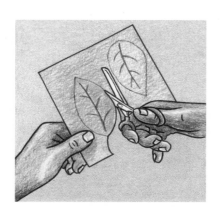

Step 1 Plan and Practice
We start with an idea.
We practice with
materials and tools.

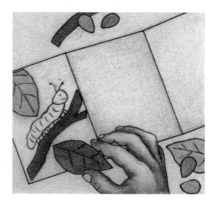

Step 2 Begin to Create
We begin to try
out our idea.

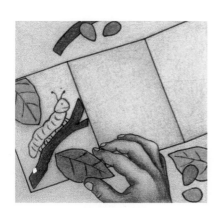

Step 3 Revise
We make changes.

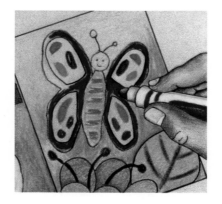

**Step 4 Add Finishing
Touches**
We add details.

Step 5 Share and Reflect
We share our work with others.
We learn from our work.

Looking Around
Seeing Our World

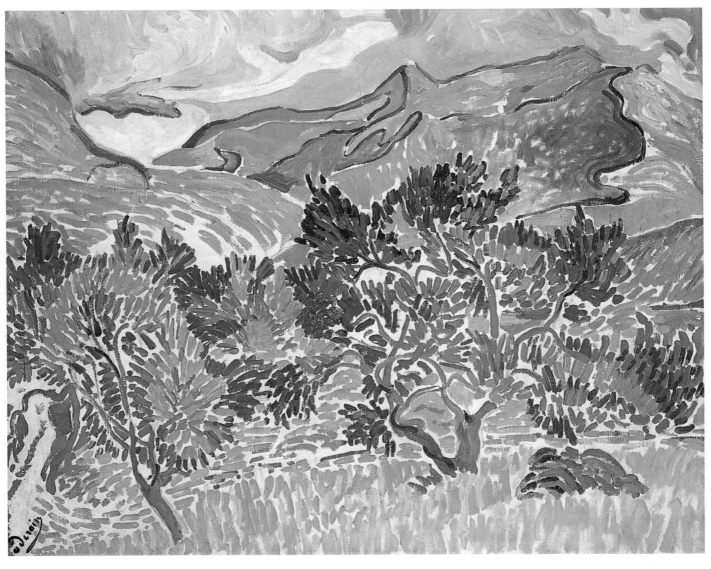

A André Derain, *Mountains at Collioure*, 1905. Oil painting.

What colors do you see in this picture?

All people like beautiful things.
An artist made pictures Ⓐ and Ⓑ.

Artists help us find beauty in our world.
They show us lines, shapes, and textures.

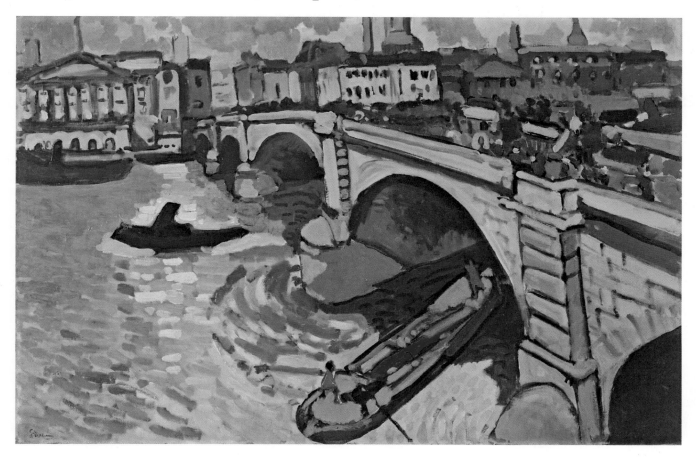

Ⓑ André Derain, *London Bridge*, 1906. Oil painting.

What lines and shapes do
you see in this picture?

Meet André Derain
He made many
paintings of
beautiful places.

Beautiful Buildings

Picture (A) is a picture of a beautiful building.

Picture (B) is a painting of the same building.
Where do you see lines in (A) and (B)?

Can you find these lines?
curved straight wavy thick thin

Vocabulary

English Spanish
line *linea*

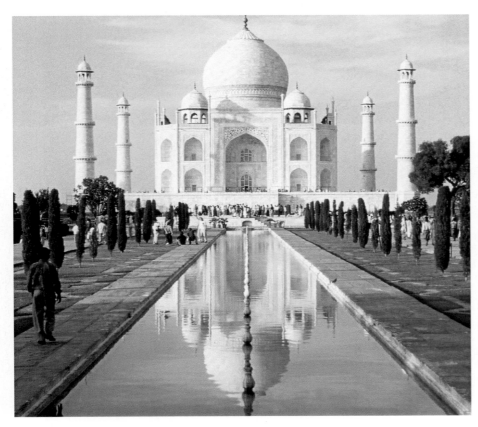

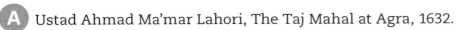

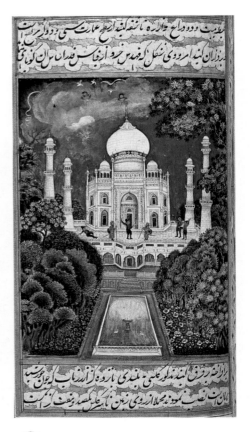

(A) Ustad Ahmad Ma'mar Lahori, The Taj Mahal at Agra, 1632.

(B) India, *The Taj Mahal at Agra, Uttar Pradesh,* 1600s. Watercolor painting.

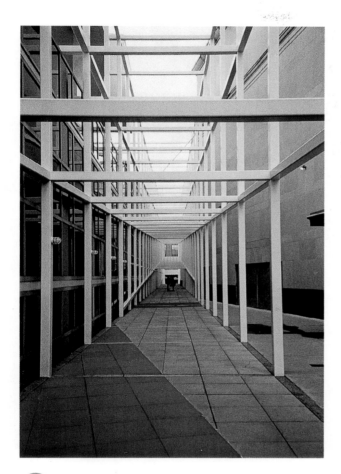

C Peter Eisenman and Richard Trott,
The Wexner Center for the Arts,
Columbus, Ohio.

This is a picture of an
outdoor walkway. What
lines do you see?

Myself in a Beautiful Place

You can draw a
beautiful place.

- Draw yourself in the
 picture.
- Where will you be?
- Show what you like
 to see.

D Student artwork

Beauty in Nature

Picture **A** shows a beautiful garden.
Where do you see lines?
Where do lines change direction?
Find some shapes.

An artist made picture **B**.
Can you find lines that go up, down, and around?
Where do you see shapes?

Vocabulary

English	Spanish
shape	*forma*
print	*impresión*

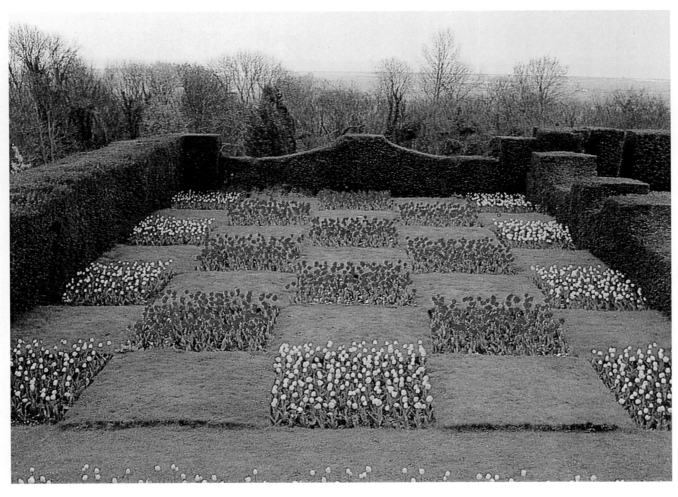

A

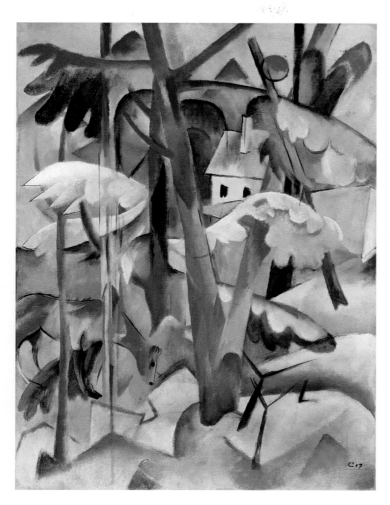

B Heinrich Campendonk, *Landscape*, 1917. Oil painting.

Lines and Shapes

Think like an artist.

- Dip a piece of cardboard into paint.
- Press down and lift up to make prints of lines and shapes.
- Make lines change direction.
- What shapes can you make?

C Student artwork

Materials you will need:
- cardboard pieces
- stamp pad
- tempera paint
- brushes

Creating Lines and Shapes
My Beautiful Place

Read, Look, and Learn

Do you have an idea for a beautiful place?

Make a picture of a beautiful place with lines and shapes.

Remember to:

✔ Use different kinds of lines and shapes.

✔ Show a beautiful place.

Step 1: Plan and Practice

- Look at the pictures on these pages.

- Can you show a beautiful place with lines and shapes?

For Your Sketchbook

Draw your ideas for a beautiful place in your sketchbook.

Inspiration from Our World

B A garden

Inspiration from Art

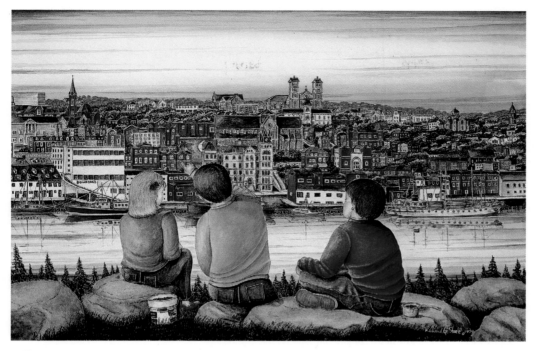

A Richard Steele, *Autumn Reflection*, 2004. Watercolor painting.

An artist painted children looking at a beautiful place. What kinds of lines and shapes do you see?

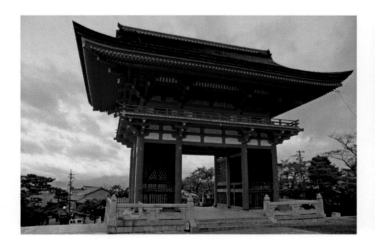

C A Japanese gate

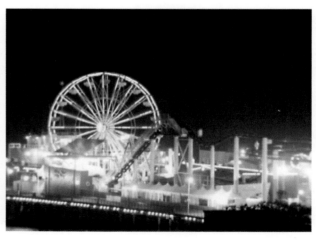

D An amusement park

Step 2: Begin to Create ——————————→

- Make lines with cardboard tools.
- Build your picture, one line at a time.
- You can change directions.

Use a stamp pad.

Step 3: Revise

- Did you make different lines?
- Did you make different shapes?

Step 4: Add Finishing Touches

- What colors will make your place more beautiful?
- Can you add more lines?
- What other details can you add?

Step 5: Share and Reflect

- Show your picture to your classmates.
- What do you like most about your picture?

Computer Option
Use a paint program to make different kinds of lines and shapes.

Press down. Lift up.

Change direction to make shapes.

Add color with paint.

Art Criticism

A Student artwork

Describe

What do you see in this picture?

Analyze

What lines and shapes help to show a beautiful place?

Interpret

Why might someone like to go to this place?

Evaluate

What is special about this artwork?

Special Objects

We can see shapes in things we use every day. What toys do you see in picture Ⓐ?

Picture Ⓑ shows **geometric** shapes.

Ⓐ

Ⓑ

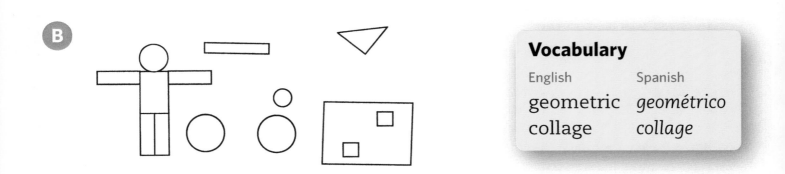

Vocabulary

English	Spanish
geometric	*geométrico*
collage	*collage*

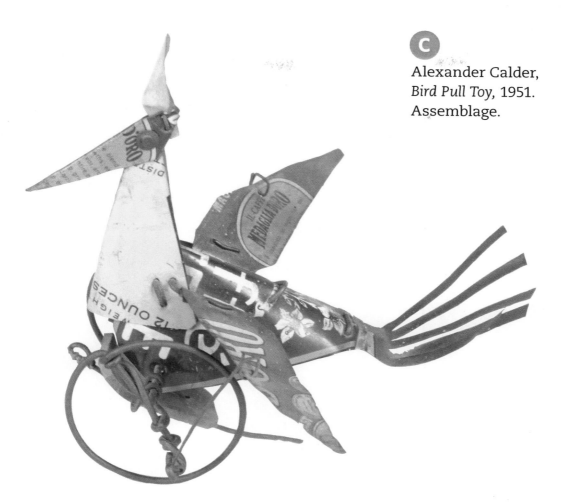

Alexander Calder,
Bird Pull Toy, 1951.
Assemblage.

An artist made the toy in picture C.
What shapes do you see?

Studio Time

A Collage

Be an artist.
Create a collage of a toy.

- Cut some shapes from paper.
- Paste them on another paper.
- What toy can you show?

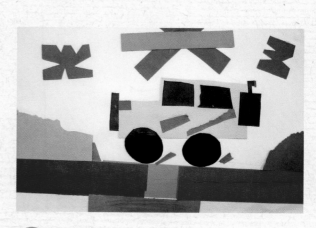

D Student artwork

Everyday Objects

Picture (A) is a painting.
What objects do you see on it?

Picture (B) shows **free-form** shapes.
Can you find these shapes in picture (A)?

Vocabulary

English	Spanish
free-form	*forma libre*

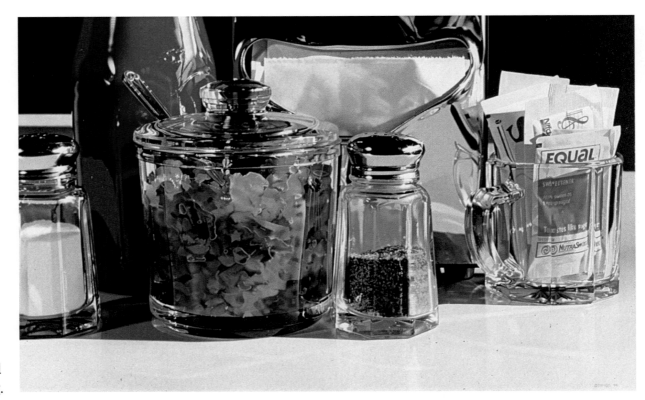

(A)
Ralph
Goings,
Relish,
1994. Oil
painting.

(B)

14

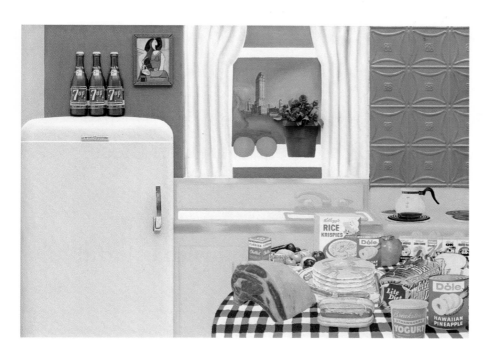

The artwork in picture **C** shows a kitchen.
What shapes do you see?

Studio Time

Mealtime

Show how a table looks at
mealtime.

- Draw some objects.

- Cut out the shapes.

- Plan how you will put them
on a table.

D Student artwork

Arranging Shapes and Lines
A Beautiful Playground

Read, Look, and Learn

Artists plan playgrounds.

They use many different lines and shapes.

You can plan a beautiful playground.

Remember to:

✔ Choose free-form and geometric shapes.

✔ Cut large and small shapes.

Step 1: Plan and Practice

- Look at the playgrounds in the pictures on these pages.

- How can you show a playground with colorful shapes?

Inspiration from Our World

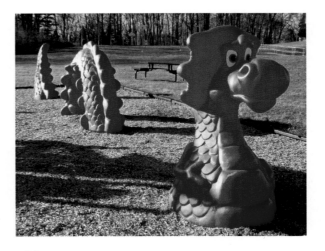

B A playground serpent

For Your Sketchbook

Use your sketchbook to practice drawing geometric and free-form shapes.

Inspiration from Art

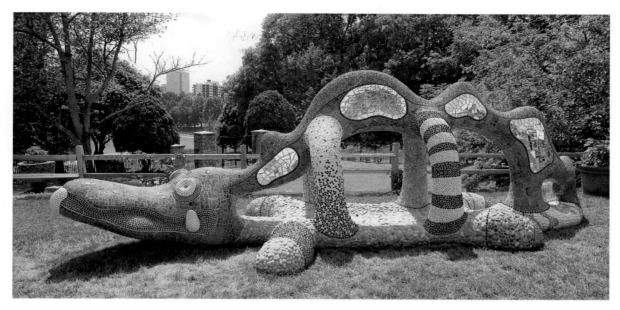

A Niki de Saint Phalle, *Nikigator*, 2001. Sculpture.

An artist created this large artwork for children to play on.

Imagine playing here.

How would you play here?

C Playground rings

D A jungle gym

Step 2: Begin to Create ──────▶

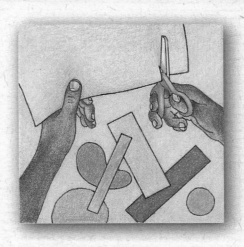

- Build your picture, one shape at a time.

- You can combine shapes.
 You can put one shape on top of another.

- You can combine large and small shapes.

Cut out paper shapes.

Step 3: Revise

- Did you choose geometric and free-form shapes?

- Do you have large and small shapes?

Step 4: Add Finishing Touches

- Can you add smaller shapes?

- Can you add more lines?

Step 5: Share and Reflect

- Tell classmates about your finished picture.

- Tell what you like most about your playground.

For Your Portfolio

A portfolio can be a folder to keep your artwork.

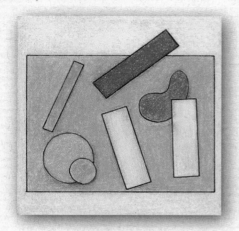
Put shapes together.

Glue them down.

Add details with oil pastels.

Art Criticism

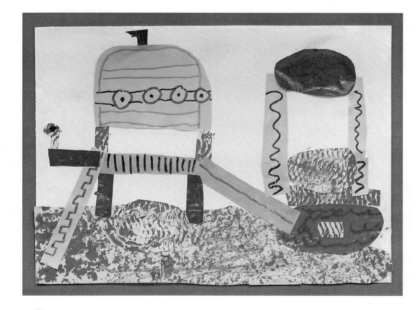

A Student artwork

Describe
What do you see?

Analyze
How do lines and shapes show a playground?

Interpret
Why might someone like to play here?

Evaluate
What is special about this artwork?

Beauty in Nature

Everything has a texture we can feel.

Textures can be rough or smooth.
Textures can be fluffy or bumpy.

Pretend you can touch the things in these pictures.
How might they feel?

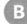

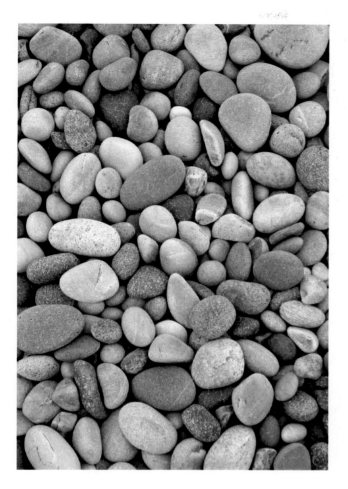

C

Look around.

Where else can you find textures?

Nature Rubbing

You can make a rubbing.

- Find texture in nature.
- Put paper on top.
- Rub with crayon.

- Do you see texture?

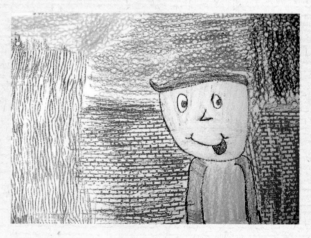

D Student artwork

Looking at Creatures

An artist made a picture of an animal. The artist created small **patterns** to show the texture of the skin.

Vocabulary

English	Spanish
pattern	*patrón*

Patterns have repeated lines and shapes. Can you find these patterns in the texture of the animal?

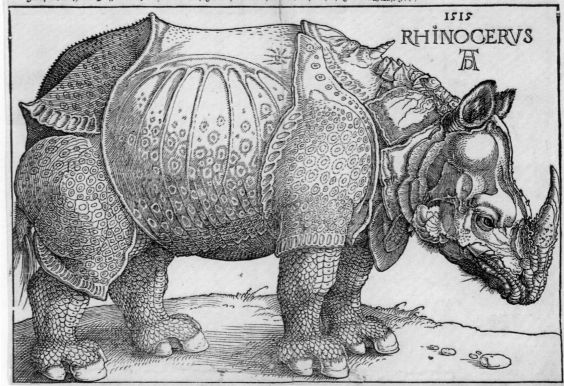

 Albrecht Dürer, *Rhinoceros*, 1515. Woodblock print.

Look at the drawing of a hen in picture **B**.
How did the artist show the feathers?

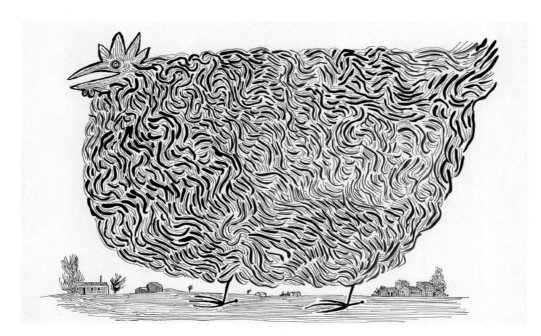

Saul Steinberg, *Hen*, 1945. Pen and ink drawing.

Studio Time

Textures to See

You can make an artwork with textures to see.

- Draw an animal.

- Combine lines and patterns to make textures.

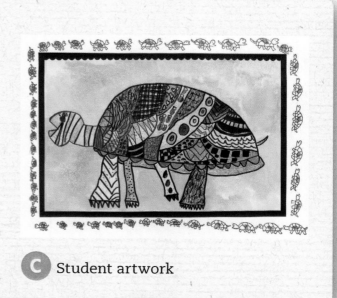

C Student artwork

Making Textures to Touch
A Beautiful Animal

Vocabulary

English Spanish

slab *losa*

Materials you will need:
- clay
- clay tools

Read, Look, and Learn

Have you ever been to a petting zoo?

What animals have you touched?

Artists think about textures when they make artworks.

You can use a clay slab to make an animal.

How will you show texture?

What animal will you make?

Remember to:

✔ Make an animal shape.

✔ Add details.

✔ Use different tools to make textures in clay.

Step 1: Plan and Practice

- Look at the animals in the pictures on these pages.

- Can you describe their textures?

Inspiration from Our World

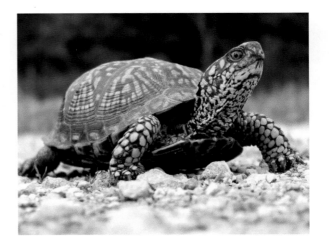

B Turtle

Inspiration from Art

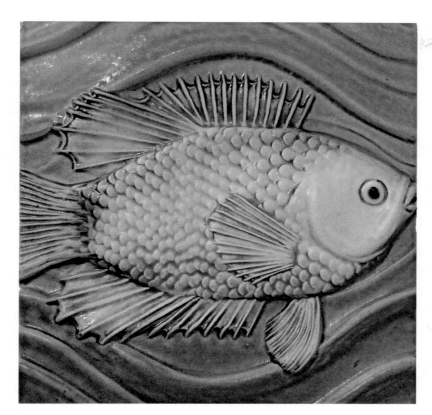

Natalie Surving,
Kissing Gourami, 2006. Clay tile.

This artist used clay to make textures you can feel.

How do some parts stand out from the background?

C Rabbit

D Hen

Step 2: Begin to Create ⟶

- Make a clay slab.

- Make your animal shape touch all four edges of the slab.

- How will you make textures and patterns?

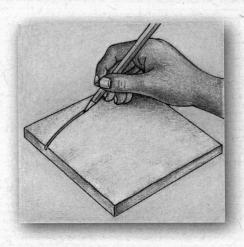

Make a clay slab.

Step 3: Revise

- Do you like your animal shape so far?

- Did you add texture?

Step 4: Add Finishing Touches

- What will make your animal look better?

- What other details can you add?

Step 5: Share and Reflect

- Tell your classmates about your animal.

- Tell how you made textures and patterns.

Computer Options

1. Use a paint program to draw an animal.

2. Add patterns using lines and shapes to show the animal's texture.

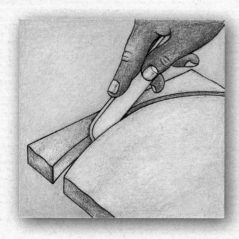

Cut out an animal shape.

Press objects into clay.

Make textures. Add clay for details.

Art Criticism

A Student artwork

Describe
What did the artist show?

Analyze
How did the artist make textures and patterns?

Interpret
Why would someone want to touch this?

Evaluate
What is special about this artwork?

Looking Around
Seeing Beauty Everywhere

In the Past

Picture **A** is a very old painting from Egypt.
It shows how people lived a long time ago.
Do you think they liked beautiful things?

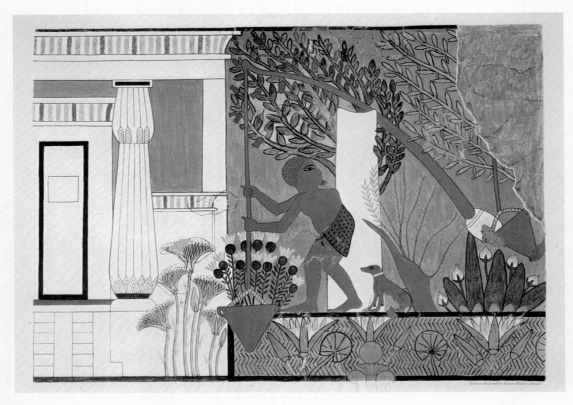

A Ancient Egypt, *The Watering of Plants in a Garden*, 1300–1200 BCE. Wall painting.

In the Past

1300–1200 BCE

1900s

28

In Another Place

Picture **B** shows a building in Niger in **Africa**. What lines, shapes, and colors do you see? What makes this a beautiful building?

Africa

Atlantic Ocean

Indian Ocean

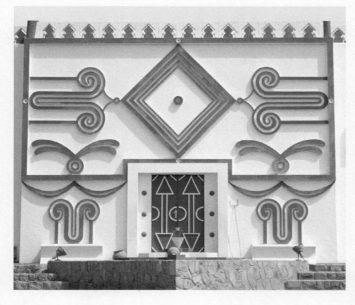

B Pavilion at National Museum, Niamey, Niger.

In Daily Life

Flower gardens can be beautiful places. Would you like to be a gardener?

In the Present

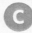

a b c

Match each phrase to a picture.

1 a painting with free-form shapes

2 a picture with geometric shapes

3 a pattern of lines that shows texture

Write About Art

Look at the painting on the next page.
If you could walk into this painting,
where would you go first?
What would you like to do in this place? Why?

Aesthetic Thinking

Does everyone agree about what is beautiful?
Why or why not?

Art Criticism

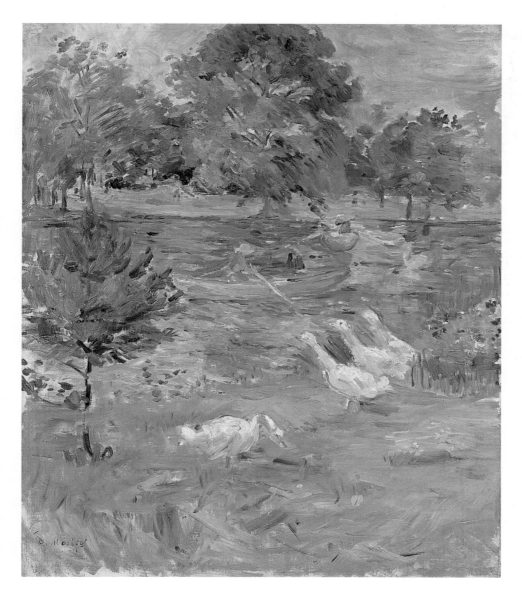

A

Berthe Morisot,
*Girl in a Boat
with Geese*, ca. 1889.
Oil painting.

Describe

What do you see?
What colors did the artist choose?

Analyze

What did the artist put in the center?

Interpret

Do you think this shows a beautiful place? Why?

Evaluate

What do you like about this painting?

People and Places
Seeing Details and Actions

A

Mary Cassatt, *The Child's Bath*, 1893. Oil painting.

What do you see in this picture?

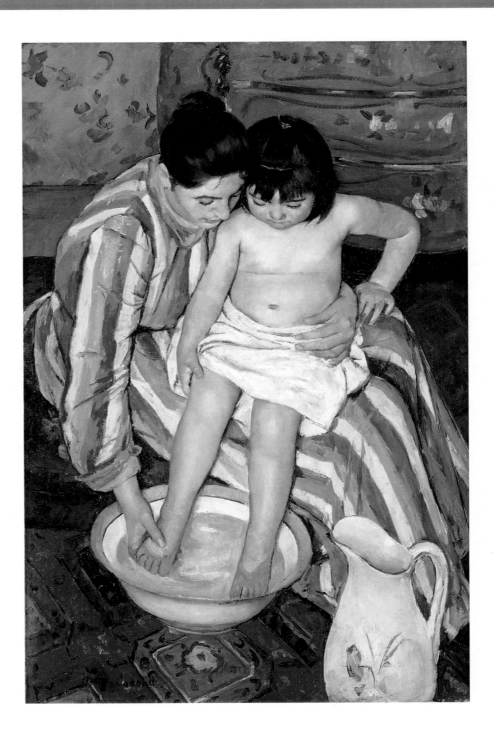

We all care about other people.

Artists show who we are and what we care about.
They look closely at people and what they do.

Look at the paintings shown in **A** and **B**.
Did this artist look closely at people? How can you tell?

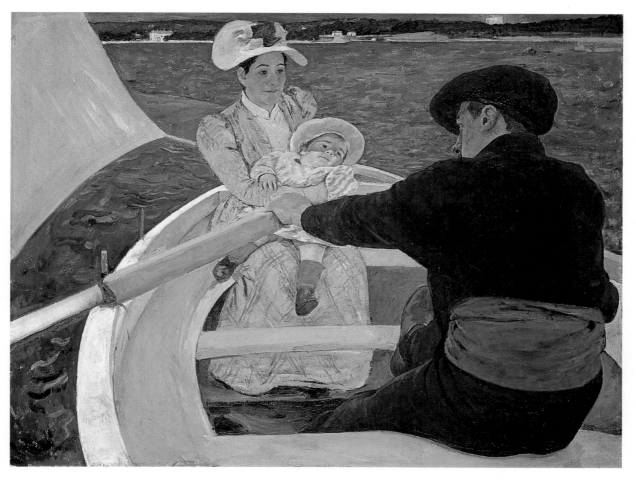

B Mary Cassatt, *The Boating Party,*
1893–1894. Oil painting.

What are the people
in this picture doing?

Meet Mary Cassatt
Mary Cassatt painted
many pictures of
mothers and children.

Who I Am

Pictures can show faces.
Faces have different shapes.

These pictures are photographs of children.
Do they all look the same?
What shapes do you see?

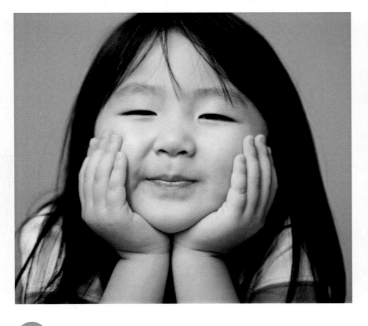

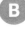

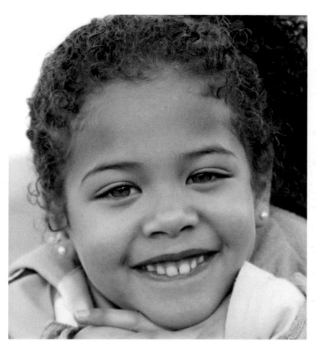

D

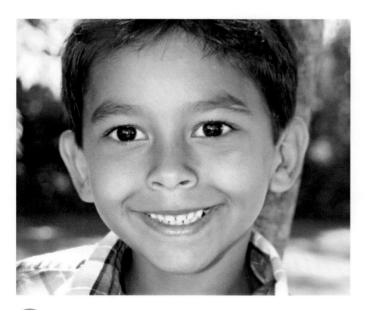

E

Make a Face

Use your hands like an artist.

- Tear paper shapes.
- Combine shapes.
- Make a collage of a face.

F Student artwork

Looking at Classmates

Vocabulary

English	Spanish
portrait	*retrato*
self-portrait	*autorretrato*

These pictures are portraits.
A portrait is a picture of a person.
A self-portrait is a picture you make of yourself.

How did each person pose in pictures **A** and **B**?

Did the girl in picture **C** pose for the portrait?
How do you know?

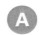

Fernando Castillo,
Portrait of Ernestina, 1937.
Oil painting.

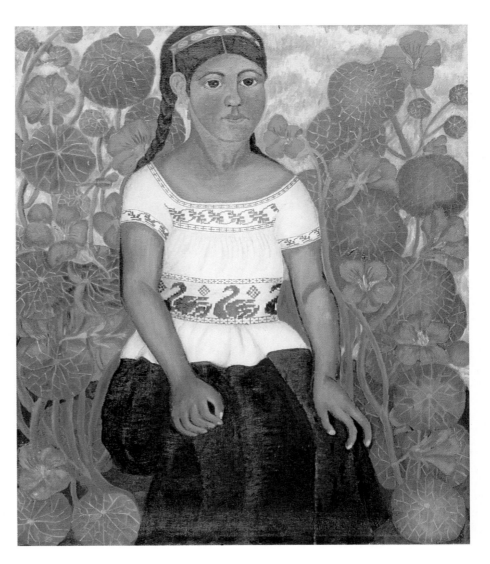

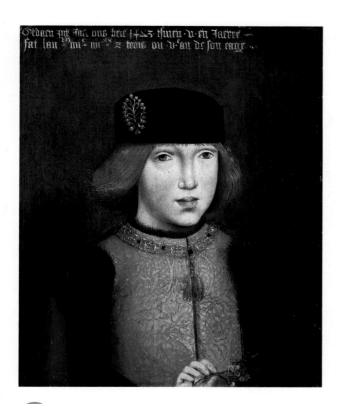

B Master of the Legend of Magdalene, *Philip the Fair*, 1483. Oil painting.

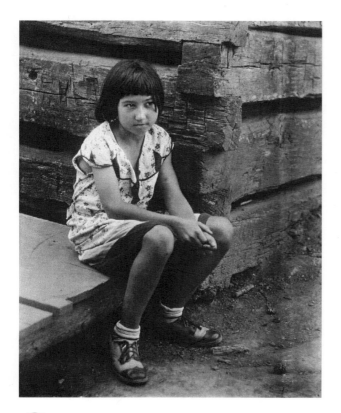

C Doris Ullmann, *Untitled*, ca. 1925–1934. Photograph.

Studio Time

Draw a Portrait

- Pose a classmate.
- Look closely at the face.
- Study the pose.
- Draw what you see.

D Student artwork

Materials you will need:
- paper
- oil pastels
- tempera paint
- brushes

Showing Expression

Special People in My Life

Read, Look, and Learn

Artists can show people they care about in their artworks.

Who are the people you care about?

You can make a portrait.

Who will you show in your portrait?

Remember to:

✔ Show people who are special in your life.

✔ Show their expressions.

Step 1: Plan and Practice

- Look at the pictures on these pages.

- How can you show that people care about each other?

Vocabulary

English	Spanish
expression	*expresión*

Inspiration from Our World

38

Inspiration from Art

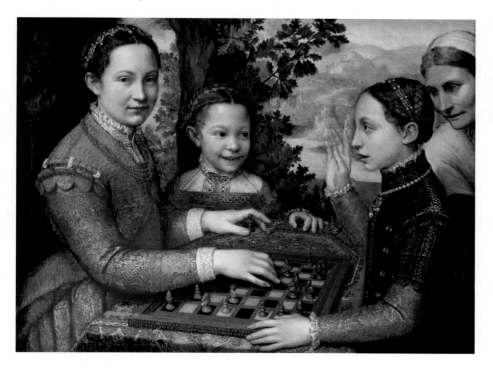

 Sofonisba Anguissola, A *Game of Chess*, 1555. Oil painting.

This is a portrait of three sisters and their friend.
Are they happy? How can you tell?

Step 2: Begin to Create ———————→

Wash.

- Draw a person. Show how the person feels.
- Add more people, one person at a time.
- Paint over your drawing.

Step 3: Revise

- Did you show people you care about?
- Did you show how they feel?

Step 4: Add Finishing Touches

- Can you add more color?
- What other details can you add?

Step 5: Share and Reflect

- Show your picture to your classmates.
- Ask them how the people feel.

Computer Option
Use a paint program to draw the face of a special person.

Wipe.

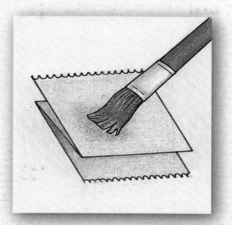

Blot.

Dip in next color.

Art Criticism

A Student artwork

Describe
What people can you
see in this picture?

Analyze
What does the artist
want you to see?

Interpret
What feelings does
this picture show?

Evaluate
Why is this a good
artwork?

Active People

Do you like to play outdoors with friends?

How do your arms and legs move around?

An artist painted children playing a game in Ⓐ. How can you show people playing?

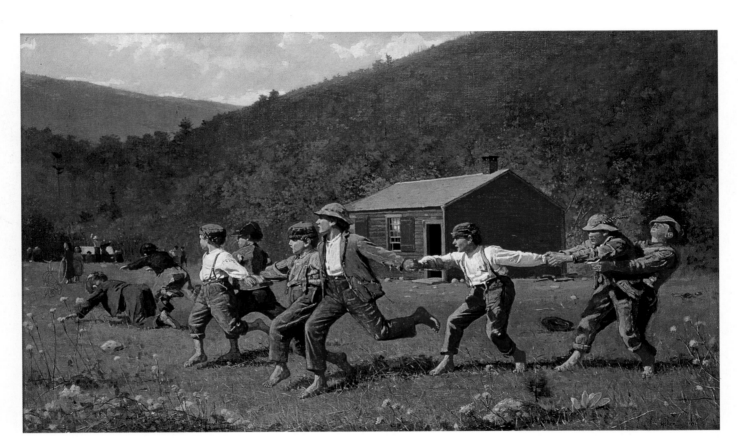

 Ⓐ Winslow Homer, *Snap the Whip*, 1872. Oil painting.

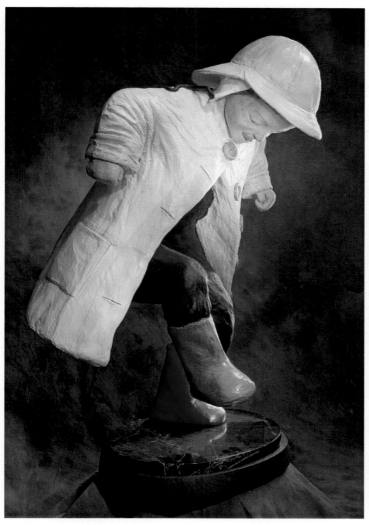

Active People

- You can draw like an artist.
- You can observe people.
- You can see how they move.

C Student artwork

B Susan J. Geissler, *Puddle Jumper,* 2005. Sculpture.

Picture B is a sculpture. You can look at it from all sides.

Fun at the Park

What did the artist paint in picture ?

How did the artist show that people are near?
How did he show that people are far away?

William Glackens,
Washington Square, 1913.
Watercolor painting.

Look at the shapes in picture **B**.
How can you tell that people are near and far away?

Studio Time

People at Play

You can draw people playing.

- Draw a park or playground.
- Show people near and far.

C Student artwork

Clay Sculpture
People Every Day

Read, Look, and Learn

Artists make sculptures of people.

They show them working.

They show them playing.

Sometimes they show them resting.

You can make a sculpture of a person.

Remember to:

✔ Show the person working, playing, or resting.

✔ Bend the arms and legs.

Step 1: Plan and Practice

- Look at the pictures on these pages for ideas.

- What are the people in the pictures doing?

- What will you show in your sculpture?

Inspiration from Our World

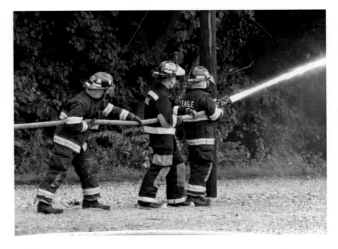

B Firefighting

Inspiration from Art

Willie Birch, *Going Home*, 1992. Sculpture.

An artist made this sculpture.
What does it show?
What are the people doing?
How are they feeling?

C Reading

D Gardening

Step 2: Begin to Create →

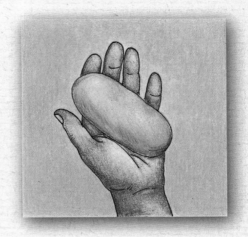

- Gently squeeze the clay in your hands.

- Start forming the head.

- How will you make arms and legs?

Shape a big lump of clay.

Step 3: Revise

- What is your person doing?

- Did you bend the arms or legs?

Step 4: Add Finishing Touches

- What details can you add?

- Make your clay smooth.

Step 5: Share and Reflect

- Display your finished sculpture.

- Tell a story about it.

- What do you like best about your sculpture?

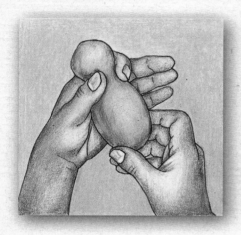

Squeeze the neck.

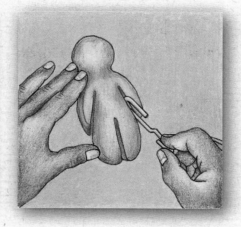

Cut slits for legs and arms.

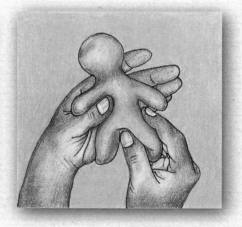

Shape the legs and arms.

Art Criticism

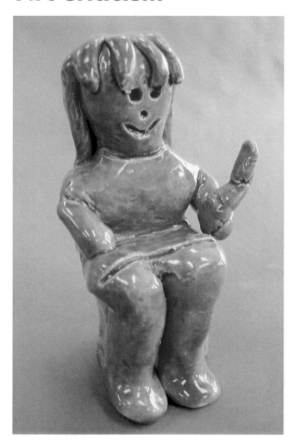

Describe

What does this sculpture show?

Analyze

What is the person doing?

Interpret

What feeling is expressed?

Evaluate

Why do you like this sculpture?

 Student artwork

A Room for My Family and Me

Jacob Lawrence made the painting in picture .
What is in the room?

Vincent van Gogh made the painting in picture **B**.
It shows his bedroom.

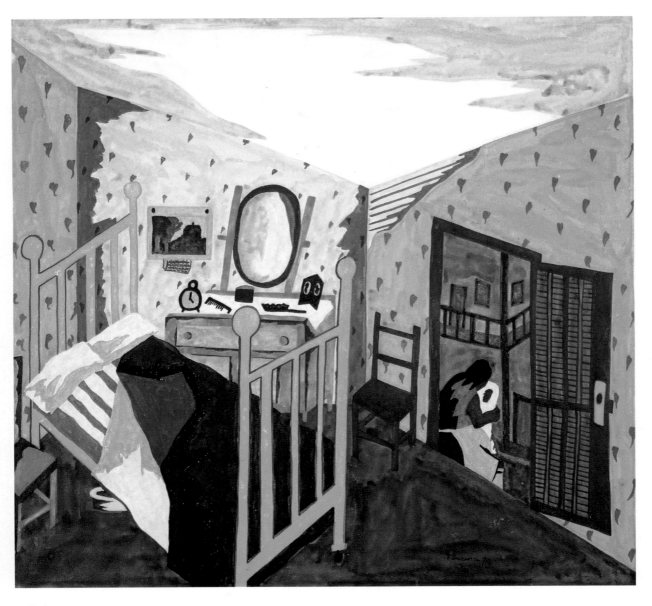

A Jacob Lawrence, *Virginia Interior,* 1942. Gouache painting.

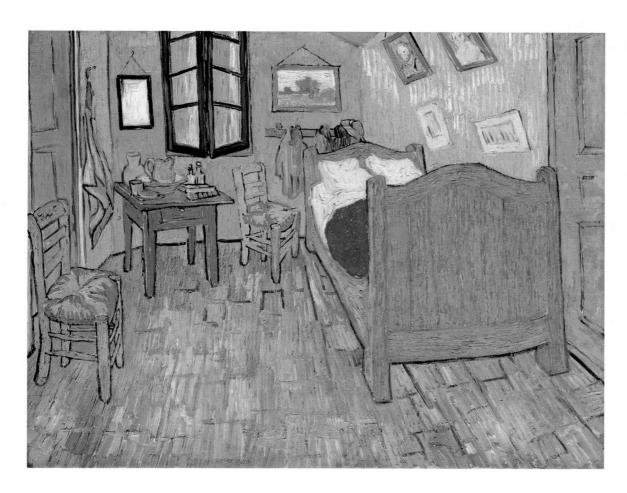

Vincent van Gogh, *The Bedroom*, 1889. Oil painting.

What is the same in pictures A and B?
What is different?

Plan a Room

What kind of room can you show?

- What will you put in your room?
- What colors will you choose?

C Student artwork

Neighborhood Buildings

Some artists plan how buildings look.
These artists are called architects.

Look at the building in picture Ⓐ.
Find shapes like the ones in picture Ⓑ.

Ⓐ

Charles Bulfinch, Church
of Christ, Lancaster,
Massachusetts, 1816.

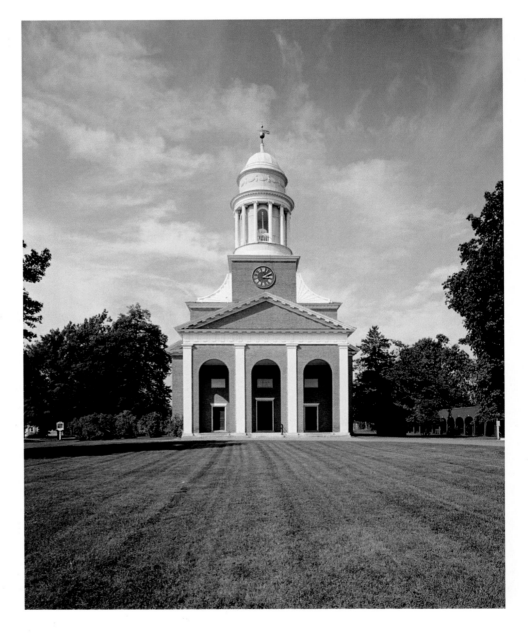

B

Shapes in Buildings

Work like an architect.
Plan a building.

- Cut big and little
 shapes.
- Arrange the shapes
 on paper.
- Glue them down.

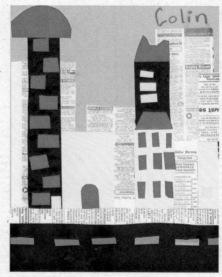

C

Student artwork

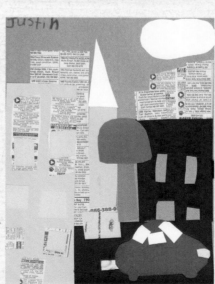

D

Student artwork

Designing with Forms
Planning Our Town

Materials you will need:
- construction paper
- scissors
- glue
- markers

Read, Look, and Learn

Architects plan the forms of buildings.
You see the forms from all sides.
You can make a model of a building.
Plan a town with your classmates.

Remember to:

✔ Make a form.

✔ Add cut-paper shapes for details.

Step 1: Plan and Practice

- What forms will you use in your building?

- Look at the pictures on these pages for ideas.

Vocabulary

English	Spanish
form	*forma*
model	*modelo*

Inspiration from Our World

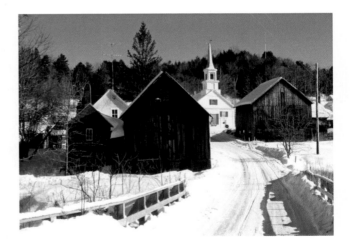

B A country town

Inspiration from Art

A Frank Stella,
Dresden Project, view 3 art form, 1992.
Architectural model.

Frank Stella made this model for a city park.

What do you see?

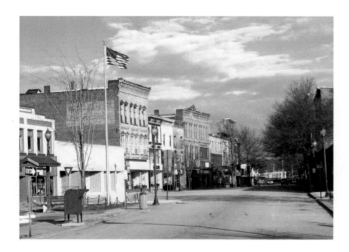

C A downtown

D A park in the city

Step 2: Begin to Create ————————————→

- Decide on a building to make.
- What forms will you use?
- What shapes will you include?

Fold paper.
Make some forms.

Step 3: Revise

- Do the parts of your building fit together?
- What details can you add?

Step 4: Add Finishing Touches

- How will you show windows?
- How will you show doors?

Step 5: Share and Reflect

- Put your building with those made by your classmates.
- Plan your town.

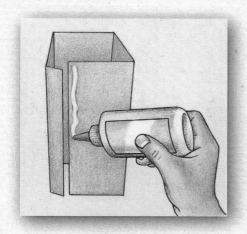

Glue parts together.

Add details.

Your class can design a make-believe town.

Art Criticism

 Student artwork

Describe
What buildings do you see?

Analyze
How are they arranged?

Interpret
Who might live or work here?

Evaluate
Is this a good plan for a town? Why?

People and Places

Showing Who We Are

In the Past

Picture shows a woman named Mona Lisa. An artist painted this portrait a long time ago.

People still wonder about her smile. What do you notice about Mona Lisa?

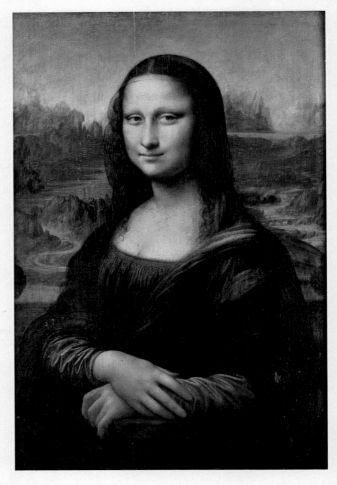

A Leonardo da Vinci, *Mona Lisa*, 1503–1506. Oil painting.

In the Past

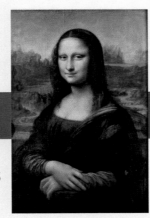

1503–1506

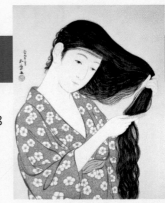

1928

In Another Place

This print in picture **B** was made in **Japan**. What does it show? How is it like the Mona Lisa?

Sea of Japan

Japan

Pacific Ocean

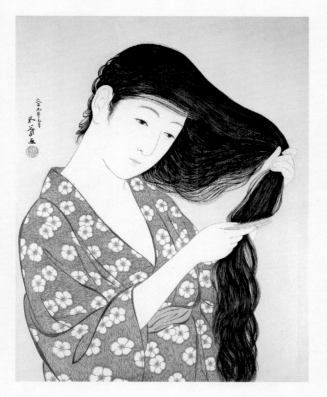

B Hashiguchi Goyo, *Woman Combing Her Hair*, 1928. Woodblock print.

In Daily Life

People care about their hair. What does this picture show?

In the Present

C Dale Kennington, *Barber Shop*, ca. 1995. Oil painting.

a

b

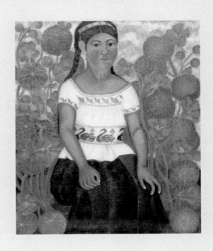

c

Match each phrase to a picture.

1 a portrait

2 a park plan

3 making a clay sculpture

Write About Art

Look at the picture on the opposite page.
Write a letter to a friend.
Tell what you like about the painting.

Aesthetic Thinking

Could an artist make a portrait of a building?

Art Criticism

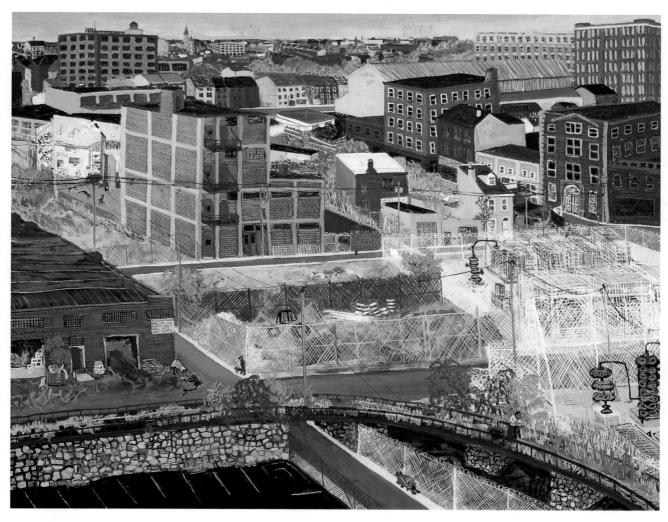

A Sarah McEneaney, *Callowhill Neighborhood*, 2002. Tempera painting.

Describe
What did the artist see in her city?

Analyze
How did she show things far away?

Interpret
Is this scene calm or busy? Why?

Evaluate
What do you like most about this painting?

Colorful Stories
Color and Imagination

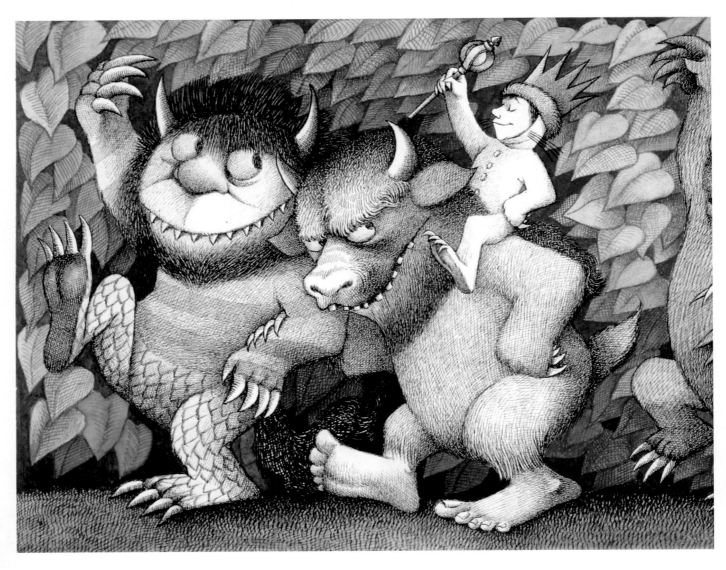

A Maurice Sendak, from *Where the Wild Things Are*, 1963. Pen and ink illustration.

Who seems happy in this picture?

People use their imaginations
to tell each other stories.
Artists often tell stories in the artworks they make.

They mix paint to make different colors.
They mix paint to make colors dark or light.

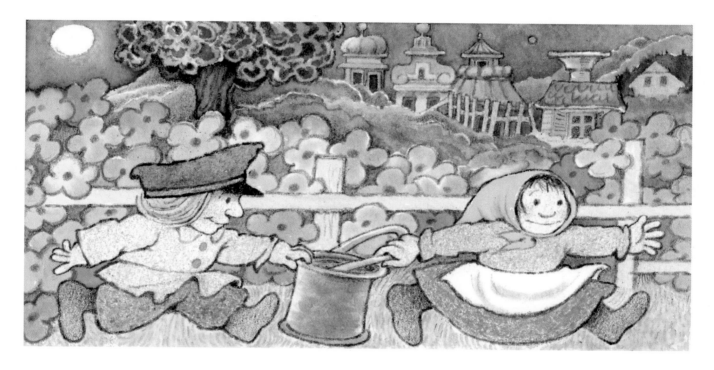

B Maurice Sendak, from *Brundibar*, 2003. Pen and ink illustration.

What is happening in this picture?

Meet Maurice Sendak

Maurice Sendak is a
writer and illustrator
of books for children.

A Story About a Castle

Can you name the colors in picture **A**?
Which colors are the primary colors?

Which primary colors make orange?
Which primary colors make green?
Which primary colors make violet?

Orange, green, and violet are secondary colors.

Vocabulary

English	Spanish
primary colors	*colores primarios*
secondary colors	*colores secundarios*

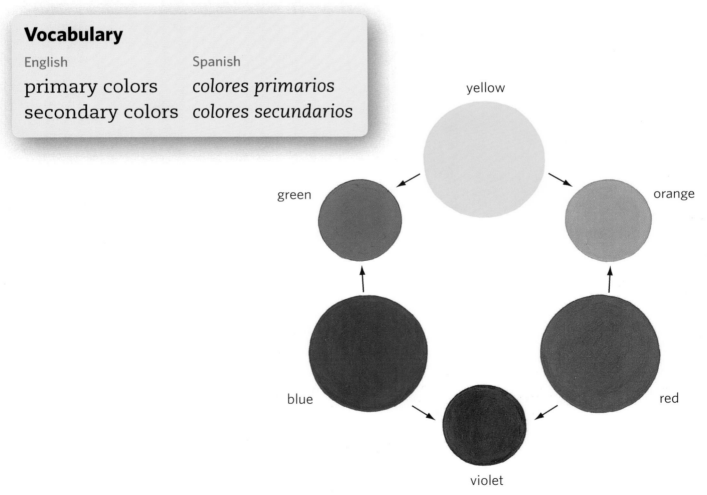

yellow

green orange

blue red

violet

A Color wheel

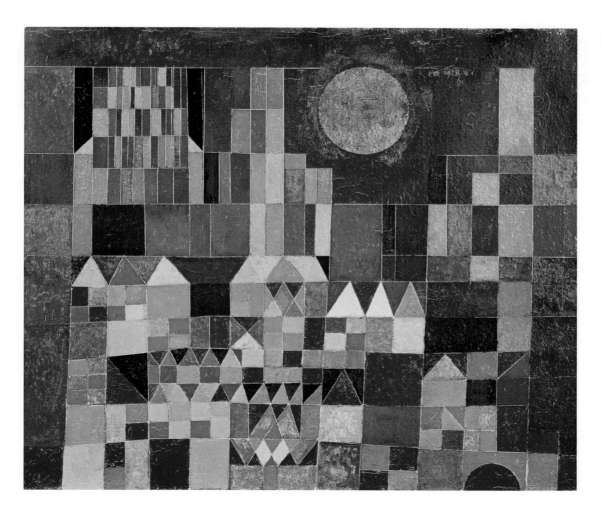

Which primary and secondary colors
do you see in picture B ?

My Colorful Castle

Paint a story about a castle.

C

Student artwork

- Put yourself in the story.
- What colors do you need?
- What colors can you mix?

A Story Setting

Vocabulary

English — Spanish

setting — *escenario*

Sometimes artists let colors
run together.
The colors mix and make fuzzy edges.

A painting can make us think of a story setting.

What shapes and colors do you see in A?
What kind of story might happen here?

A

Wassily Kandinsky,
*Improvisation 31
(Sea Battle)*, 1913.
Oil painting.

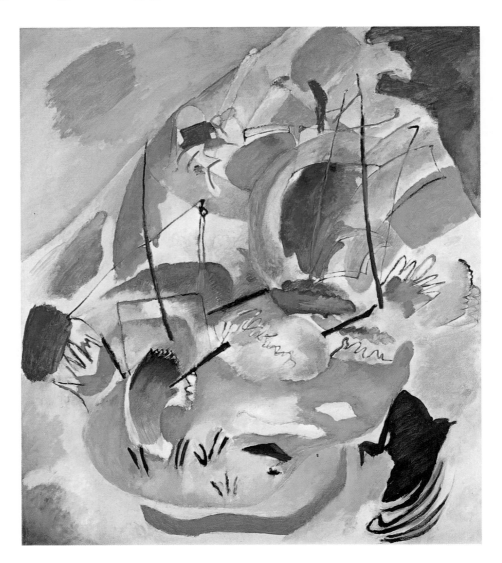

Look at picture **B**.
Could this be a setting
for a story?

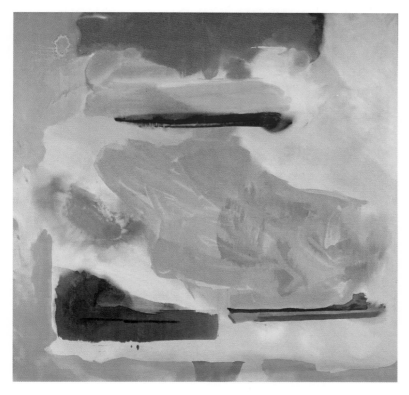

A Story Setting

Use your paintbrush.
Mix different colors.
Paint a make-believe
story setting.

- Paint on wet paper.
- Let the colors run together.
- See the fuzzy edges.

C Student artwork

Color and Detail
Telling a Make-Believe Story

Materials you will need:
- chalk
- tempera paint: red, yellow, blue, black, and white
- paintbrush
- paper
- oil pastels

Read, Look, and Learn

Stories always have a main character in a setting. Sometimes the setting is make-believe. A character can also be make-believe. You can paint a story about a make-believe creature. You can paint the story's make-believe setting.

Remember to:

✔ Mix your colors.

✔ Add details to show the creature in a setting.

Step 1: Plan and Practice

- How will the make-believe setting look?

- How will the make-believe creature look?

- Look at the pictures on these pages for ideas.

Inspiration from Our World

B

68

Inspiration from Art

 A

Trenton Doyle Hancock, *Esther*, 2002. Acrylic painting.

This painting shows a character named Esther.

Do you think Esther is a make-believe character? Why?

Do you think this is a make-believe setting? Why?

 C

 D

Step 2: Begin to Create ──────────➤

- What big shape will you draw first?
- What other lines and shapes will you add?
- Use chalk to plan your painting.

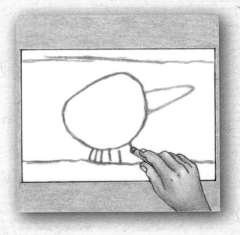

Draw a creature in a make-believe land.

Step 3: Revise

- What colors did you mix?
- What details can you add?

Step 4: Add Finishing Touches

- How will your creature stand out from the setting?
- What textures or patterns can you show?

Step 5: Share and Reflect

- Show your painting to your classmates.
- Tell about your story.
- Tell about your character.

Computer Options
Use a paint program to draw your character and setting.

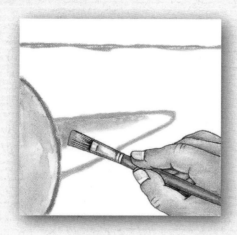

Paint your creature.

Paint the land and background.

Use oil pastels for details.

Art Criticism

B Student artwork

Describe
What do you see?

Analyze
Where is the creature?
What is the setting?

Interpret
What story does
the painting show?

Evaluate
What is the best part
about this painting?

Outdoor Stories

Artists choose their colors.
Picture **A** shows lots
of warm colors.
What is happening in this picture?

Vocabulary

English	Spanish
warm colors	colores cálidos
cool colors	colores frescos

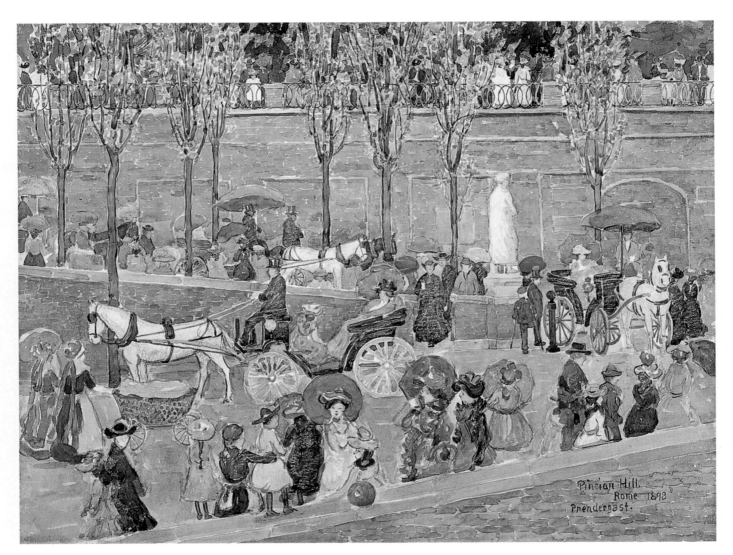

A Maurice Prendergast, *Pincian Hill, Rome,* 1898. Watercolor painting.

Picture **B** shows lots of cool colors.
What story might happen in this place?

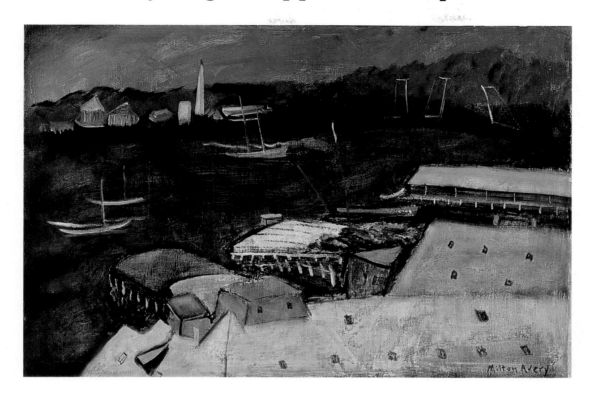

Studio Time

Color Families

Draw a story that
happens outdoors.

- Choose colors like
an artist.

- Why might you
choose cool colors?

- Why might you
choose warm colors?

warm colors

cool colors

C Student artwork

Colorful Weather Stories

Artists can tell stories
about the weather.
Colors help tell the story.
What story does picture **A** tell?

Artists learn to mix colors.
Where do you see light and dark colors?

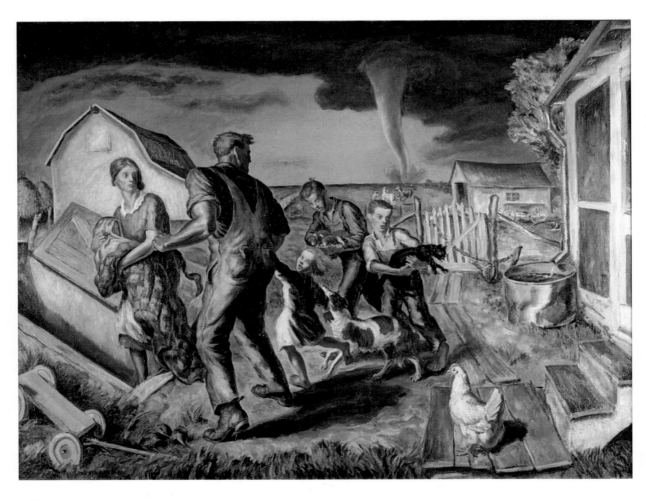

A John Steuart Curry, *Tornado Over Kansas*, 1929. Oil painting.

Light and Dark

You can tell a story about weather.

Mix some paint colors.

• What story will you tell?

• What colors will you use?

• How will you mix your colors?

C Student artwork

B

You can mix paint.
You can mix light and dark colors.
You can mix tints and shades.

Painting Characters in a Setting
Telling a Real Story

Materials you will need:
- paper
- tempera paint
- brushes

Read, Look, and Learn

Every story has a setting.

You can paint a setting for a story.

Paint a story about you and your friends.

Remember to:

✔ Paint the characters in your story.

✔ Paint a colorful setting for your story.

✔ Mix tints and shades.

Step 1: Plan and Practice

- Where will your story take place?

- Will you show sky? Will you show ground?

- Look at the pictures on these pages for ideas.

Inspiration from Our World

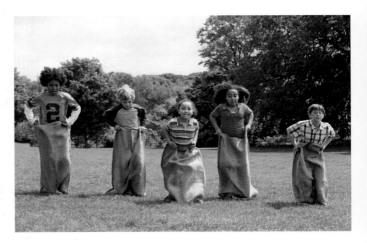

B A sack race

Inspiration from Art

A Carmen Lomas Garza, *Cakewalk*, 1987. Acrylic painting.

This painting is about a cakewalk.

The cakewalk takes place on a street.

What else can you see?

C Playing with pets

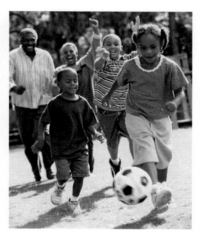

D Family soccer

Step 2: Begin to Create ⟶

- Use paint to show the main parts of your setting.

- Show the people in your story.

Draw the main parts of your setting.

Step 3: Revise

- Did you show characters in a setting?

- Have you mixed tints and shades?

Step 4: Add Finishing Touches

- What details can you add?

- Is anything missing that you want to show?

Step 5: Share and Reflect

- Write about your painting.

- What story does your painting tell?

- Tell what you want others to see.

Show a setting and characters.

Use a large brush to add color.

Use a small brush to add details.

Art Criticism

A
Student artwork

Describe
What do you see?

Analyze
How did the artist arrange colors?

Interpret
What is this story about?

Evaluate
What do you like most?

Illustrating a Story

Some artists illustrate books.
They make pictures for stories.
The artwork goes with the story.

What ideas are in this book?

Vocabulary

English Spanish

illustrate *ilustrar*

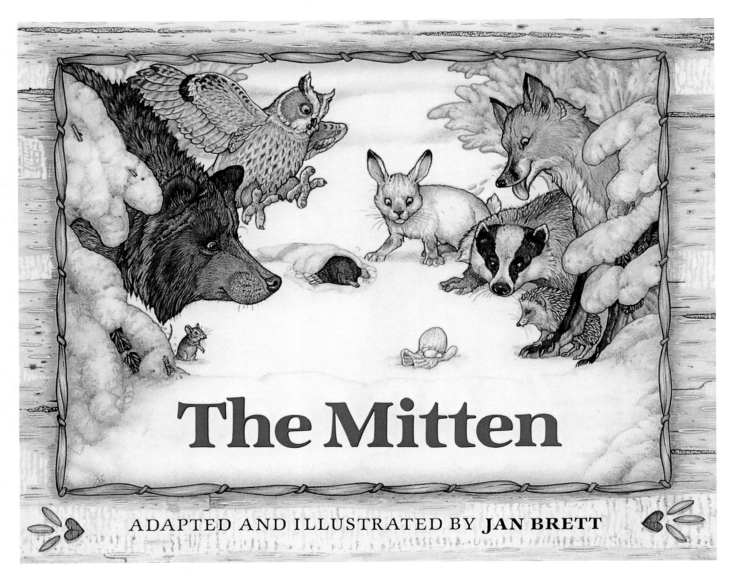

A Jan Brett, from *The Mitten*, 1989. Watercolor illustration.

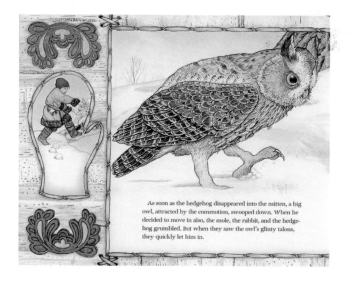

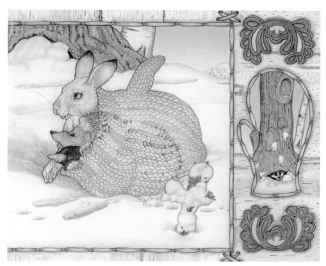

B Jan Brett, from *The Mitten*, 1989. Watercolor illustration.

A Colorful Poem

Make a picture for the poem *Sudden Storm*.

- What ideas will you illustrate?
- What colors will you need?

Sudden Storm

The rain comes in sheets.
Sweeping the streets,
Here, here, and here,
Umbrellas appear,
Red, blue, yellow, green,
They tilt and they lean
Like mushrooms,
 like flowers
That grow when it
 showers.

Elizabeth Coatsworth

What Happens Next?

Vocabulary

English	Spanish
frame	*marco*

Picture **A** is a story
with four parts.
Each part is called a frame.

Look at each frame.
What stays the same?
What changes?

A Jim McNeill, *Hungry Dino*, 2006. Digital illustration.

About the Artist
Jim McNeill uses a computer to help
him create pictures and illustrations.

What happens in the story in picture ?
What never changes?

B Jim McNeill, *Jumper,* 2006. Digital illustration.

Studio Time

Story Strip

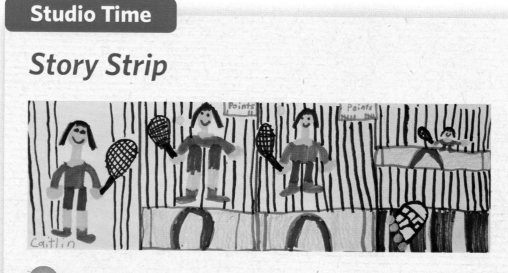

C Student artwork

You can tell a story with pictures.

- Fold your paper into four parts.

- In the first part, show how the story begins.

- In the other parts, show what happens next.

Materials you will need:
- plain index cards
- colored construction paper
- crayons
- markers

Constructing a Story Book

A Pocket Book for Stories

Read, Look, and Learn

Every story has a beginning.
Every story has an end.
Things happen in between.

Use pictures and words to tell a story with a beginning and an end.

Tell what happens in between.

Remember to:

✔ Tell your story with four different parts.

✔ Show some things the same.

✔ Show some things different.

Step 1: Plan and Practice

- Show your character in four ways.

- Look at the pictures on these pages for ideas.

Inspiration from Our World

B What's for dinner?

Inspiration from Art

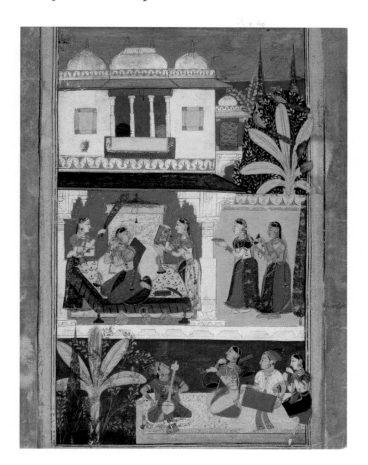

A

India, *Ragmala*, 1680. Watercolor painting.

This story painting was made long ago in India.

The story moves from one part to the next.

Can you see the different parts of the story?

C Hot dogs on the grill

D Tastes good

Step 2: Begin to Create ⟶

- Make a picture for each story card.
- Show a character in different actions.
- Show one action on each card.

Make four story cards.

Step 3: Revise

- Did you tell your story in four different parts?
- Did you show a character in different actions?
- What stays the same? What changes?

Step 4: Add Finishing Touches

- Add details to your pictures.
- Decorate your pocket book.

Step 5: Share and Reflect

- Find a partner.
- Share your story cards and pocket book.
- Can you tell your story different ways?

For Your Sketchbook

Use your sketchbook to practice making story cards. Draw a box for each action.

Make a flap by folding your paper across the bottom.

Fold the whole piece of paper in half. Fold each side in half again to make an accordion.

Put your story cards in the pockets to tell a story.

Art Criticism

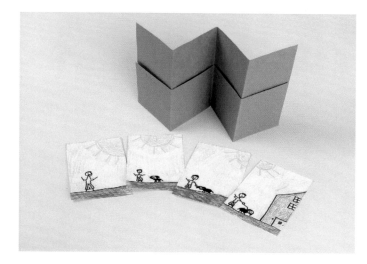

A Student artwork

Describe
How was this book made?

Analyze
How do the parts work together?

Interpret
Is this a good way to tell a story?

Evaluate
What do you like about this book?

Storytelling

Stories Are Told Everywhere

In the Past

Some objects in museums
are very, very old.
This vase was made
in the country Greece
a long time ago.
The decoration tells a story.
What are the people doing?

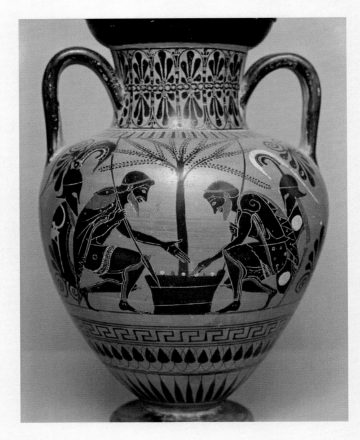

A Greek, Attic black figure amphora,
550–501 BCE. Ceramic vase.

In the Past

550–501 BCE

1900s

88

In Another Place

People in **Indonesia**
tell stories on cloth.
This piece of cloth shows
puppets in a story.
How many characters
do you see?

Pacific Ocean

Indonesia

Indian Ocean

Indonesia, Batik with "wayang"
(puppet) design, 1900s.

In Daily Life

Some artists draw cartoons.
Cartoons can tell a story.
Do you like to draw cartoons?

In the Present

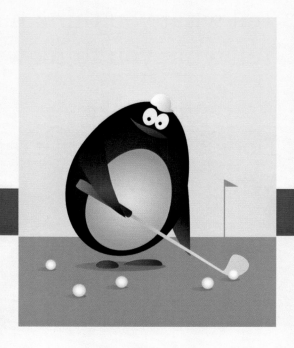

C

a

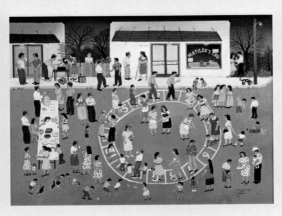
b

c

Match each phrase to a picture.

1 primary colors

2 real-life story characters

3 a make-believe story character

Write About Art

Choose an artwork in this book.

Tell what is happening in the artwork.

Tell what you think happened before.

Tell what you think will happen next.

Aesthetic Thinking

Does every artwork tell a story?

Why or why not?

Art Criticism

"Cuckoo!
Stop singing
and go to sleep!"
hooted Owl.
 He was the bird boss.
 "Early tomorrow we
start our seed collecting."

—¡Cucú, para
de cantar y
duérmete!—
ululó el Búho.
Él era el jefe
de los pájaros.
—Mañana
temprano
empezaremos
a recoger semillas.

A Lois Ehlert, from *Cuckoo: A Mexican Folktale*, 1997. Cut-paper collage.

Describe
What do you see
in this illustration?

Analyze
Where do you see shapes?
What colors are the shapes?

Interpret
How does the picture
help tell the story?

Evaluate
What do you like best
in this illustration?

Art and Nature
Getting Ideas

A

Henri Rousseau,
*The Banks of the
Bièvre near Bicêtre.*
Oil painting.

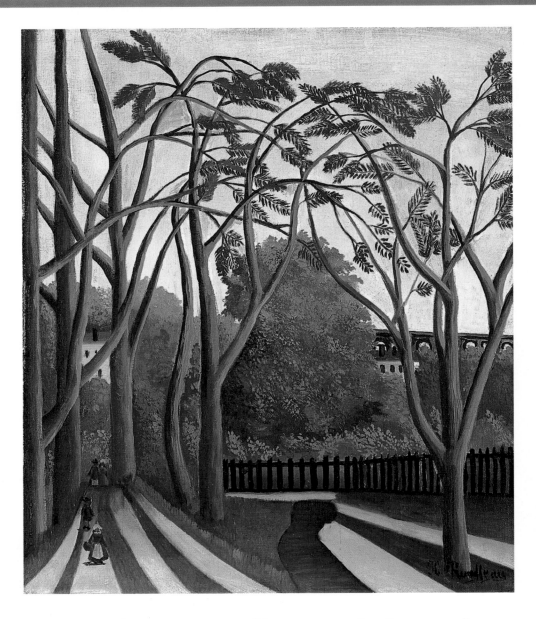

Where do you see lines and shapes?

Many people like plants and animals.

Some artists look at nature for art ideas.

Sometimes they look very closely.

Sometimes they look from far away.

What do you see in pictures A and B?

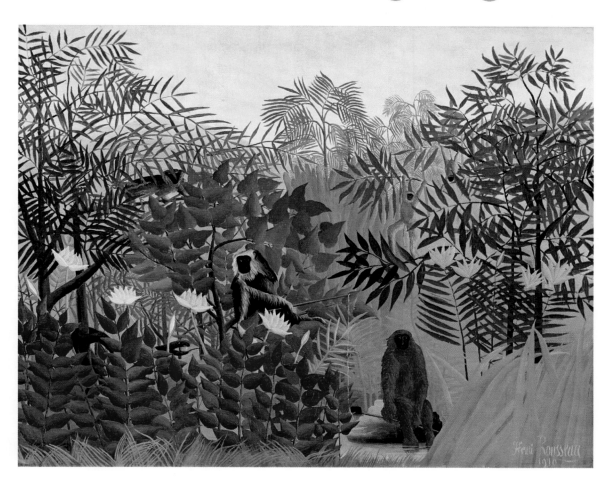

B

Henri Rousseau, *Tropical Forest with Monkeys,* 1910. Oil painting.

What colors do you see?

Meet Henri Rousseau

Henri Rousseau studied plants and animals. He painted pictures to share what he saw.

Insects Up Close

Vocabulary

English Spanish

symmetry *simetría*

Artists make pictures of insects.
The parts of the insects have **symmetry**.
The parts on the left are the same as
the parts on the right.

A

Evan Summer,
Salvazano imperalis,
2005. Graphite and
pastel drawing.

B

Suzanne Duranceau,
Leaf Insect, 2007.
Pencil and acrylic
painting.

Look at pictures
A, **B**, and **C**.
Where do you see
symmetry?

Studio Time

Bugs I See

Look at an insect up close.

Show what you see.

D Student artwork

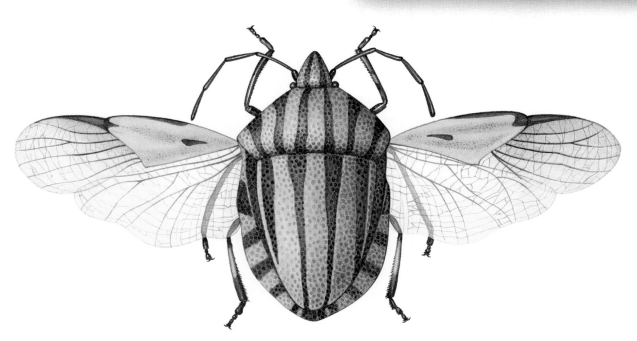

C Suzanne Duranceau, *Beetle, 2007.*
Pencil and acrylic painting.

Vocabulary

English Spanish

dab *toque*

Plant Patterns

An artist painted the picture
of flowers and insects in picture Ⓐ.
Can you find symmetry?

Find the plant shapes in picture Ⓑ.
Find the shapes that are repeated.

Ⓐ

Maria Sibylla Merian,
*Orange-flowered plant
and the life cycle of a
moth and beetle*, 1705.
Watercolor illustration.

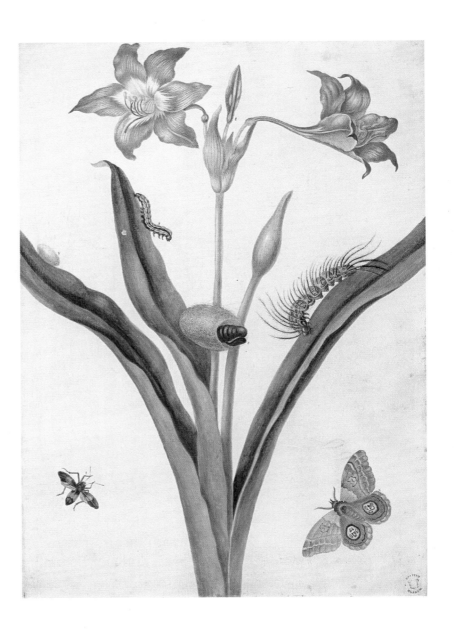

B Greece, panel from bed curtain, 1700s.

Shapes that repeat can make patterns.
What shapes come next in this pattern?

C

Colors that repeat can make patterns.
What colors come next in this pattern?

D

Stencil Shapes

You can print plant shapes and patterns.

- Cut out a leaf or flower shape.
- Dab paint inside the shape.
- Print a pattern.

E Student artwork

Materials you will need:
- colored paper
- scissors
- sponge pieces
- tempera paint
- crayons

Shape and Pattern
Fancy Flying Insects

Read, Look, and Learn

Do you have an idea for a fancy flying insect?

Make an insect with large shapes.

Make the parts fancy with small shapes, patterns, lines, and colors.

Remember to:

✔ Make shapes of insect parts.

✔ Add shapes and colors to make patterns.

Step 1: Plan and Practice

- Can you see the parts of the insect in these pictures?

- What flying insect will you make?

Inspiration from Our World

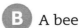 **B** A bee

Inspiration from Art

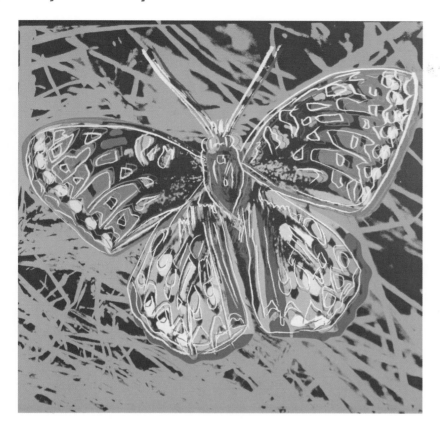

 A

Andy Warhol,
San Francisco Silverspot, 1983.
Silkscreen print.

This picture shows a print of a fancy butterfly.

What colors and shapes do you see?

Where do you see symmetry?

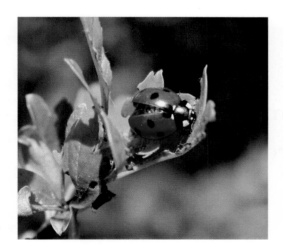

C A ladybug

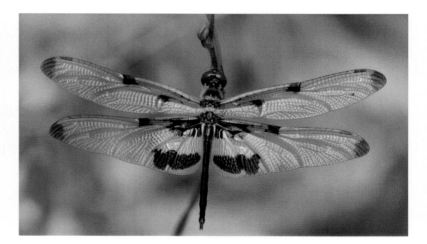

D A dragonfly

Step 2: Begin to Create ⟶

- Draw shapes of insect parts.
- You can make patterns with little shapes.
- What colors will you use?

Draw large insect parts on paper.

Step 3: Revise

- Did you show insect parts?
- Did you add small shapes?
- Did you make patterns?

Step 4: Add Finishing Touches

- What details will help your insect look fancy?
- Where can you add lines?
- Where can you add patterns?

Step 5: Share and Reflect

- Show your finished insect to your classmates.
- What do you like most about your insect?
- What do you wish you could change?

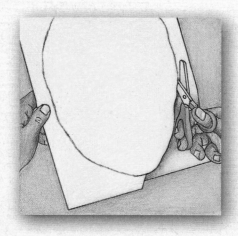

Cut out shapes.

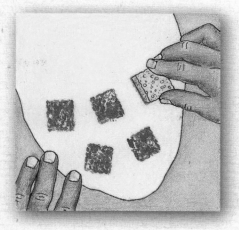

Use sponges to add shapes and colors.

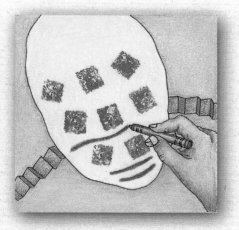

Draw details and add legs and other parts.

Art Criticism

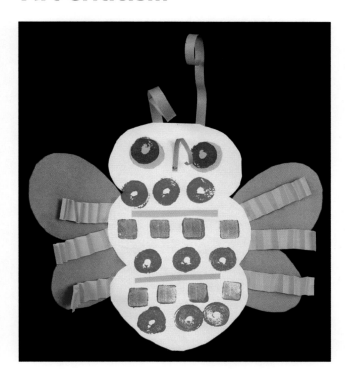

A Student artwork

Describe
What do you see?

Analyze
Where are lines and shapes repeated?

Interpret
Does this insect seem busy or quiet? Why?

Evaluate
What is special about this artwork?

Land and Sky

Artists paint pictures of places in nature. They show places up close and far away.

What place did the artist show in picture ?

Tom Thomson, *Northern River*, 1915. Oil painting.

What did the artist show up close in picture 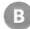?
What did he show far away?

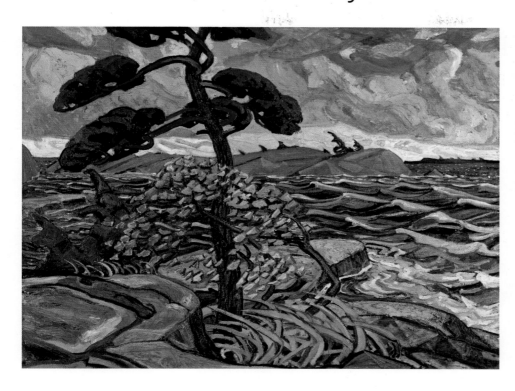

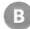
Arthur Lismer,
A *September Gale*,
Georgian Bay, 1920.
Oil painting.

Studio Time

Make a Monoprint

Use paint.

Draw some lines.

Put paper down.
Rub it.

Lift up the paper.

Patterned Landscapes

Some artists see patterns in nature.
Where are patterns in picture **A**?
What colors do you see?

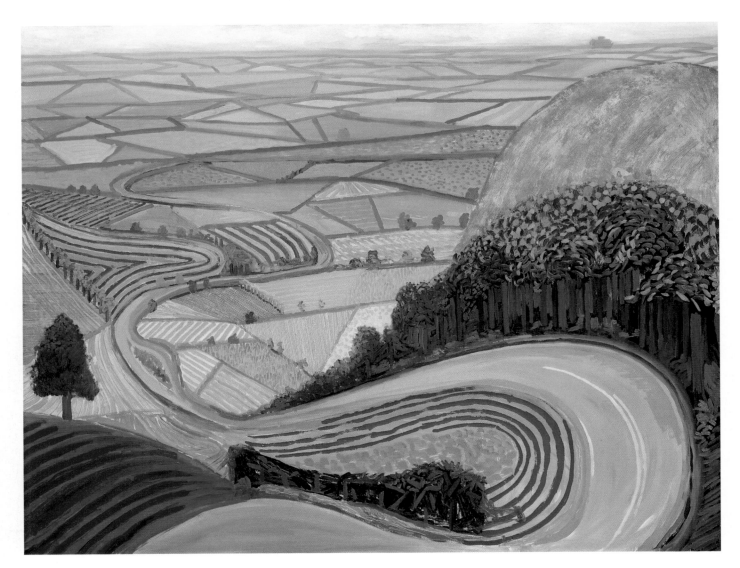

A David Hockney, *Garrowby Hill,* 1998. Oil painting.

B

Franz Morgner,
Field-path, 1912.
Oil painting.

How did the artist plan picture B ?
Where do you see lines and patterns?

Studio Time

A Land of Patterns

You can make a
patterned landscape.

- Plan the parts of the
 landscape.

- Separate the parts
 with different colors
 and patterns.

C Student artwork

Materials you will need:
- construction paper
- oil pastels
- tempera paint
- water
- brushes

Resist Painting
Nature at Night

Read, Look, and Learn

How does nature look at night?
What color is the sky?
What color are the trees?

You can make a picture of nature at night.

Remember to:

✔ Plan your picture.

✔ Cover most of your paper with your drawing.

✔ Add details.

Step 1: Plan and Practice

- Look at the pictures on these pages.
- What do you see?
- What will you show in your picture?

Inspiration from Our World

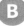

Inspiration from Art

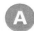

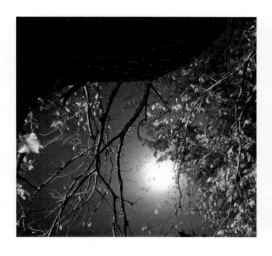

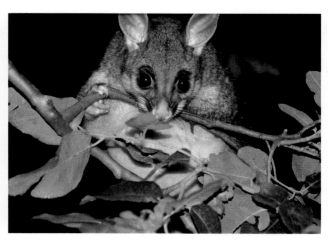

A

Henri Rousseau, *Carnival Evening*, 1886. Oil painting.

Henri Rousseau created this painting.

What do you see?

How do you know it is nighttime?

C

D

Step 2: Begin to Create ⟶

- You can plan the sky.
- You can plan the land.
- You can plan to show creatures awake at night.

Draw with oil pastels.

Step 3: Revise

- How did you plan your picture?
- Does your drawing cover most of the paper?
- Does your picture show nature at night?
- Can you see all the parts?

Step 4: Add Finishing Touches

- Can you add more color?
- What other details can you add?

Step 5: Share and Reflect

- Show your picture to your classmates.
- What do you like about your picture?

Add lots of details.

Color in large areas.

Brush paint over your picture.

Art Criticism

A Student artwork

Describe
What did the artist show?

Analyze
What do you see first?

Interpret
Does this picture seem busy or quiet? Why?

Evaluate
How is this artwork special?

Animal Alphabets

Some artists design alphabet books.
What alphabet books do you like?

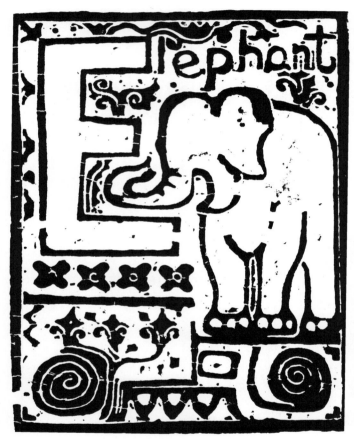

A Walter Anderson, from *An Alphabet Book,* ca. 1945. Linoleum block print.

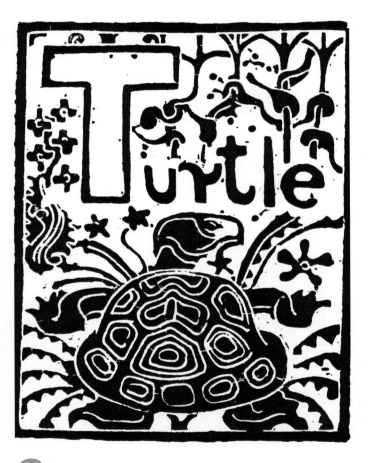

B Walter Anderson, from *An Alphabet Book,* ca. 1945. Linoleum block print.

Vocabulary

English	Spanish
alphabet book	*libro alfabético*

Artists design letters of the alphabet.

How are these letters alike? How are they different?

C

Studio Time

Animal ABCs

D
Student artwork

You can design a letter for a class alphabet book.

- Use markers.

- What letter will you design?

- What animal will you show?

Creature Collage

Artists can get ideas from creatures in nature.
Artists plan the shapes in their artwork.

Look at picture **A**.
What creature do you see?
What shape do you see?

Can you find this shape in picture **B**?

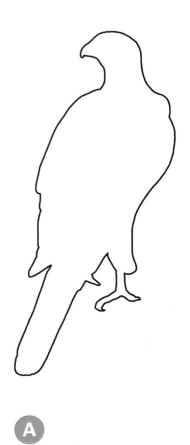

A

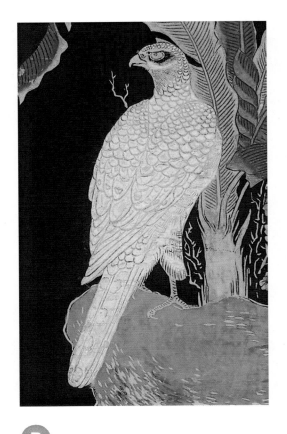

B

Isoda Koryusai,
The White Falcon (detail),
ca. 1782. Woodblock
print.

Look at picture C.
What shape do you see?
Can you find this shape
in picture D?

C

D Luis Benedit, *Pullet*, 1963. Oil painting.

Cut-Paper Creatures

Make a paper creature.

- Cut main shapes.
- Add smaller shapes.
- Add details
 with crayons and
 paper strips.

E Student artworks

Materials you will need:
- clay
- clay tools

Natural Forms
Clay Creatures

Read, Look, and Learn

Do you like to look at animals?

Some artists make sculptures of animals.

You can make a sculpture of an animal.

You can use clay.

Remember to:

✔ Pinch your clay to make an animal form.

✔ Pose your animal sculpture.

Step 1: Plan and Practice

- What animal will you create?

- Look at the pictures on these pages for ideas.

- Is your animal a pet, or is it a zoo or a farm animal?

Vocabulary	
English	Spanish
pinch	*pellizcar*
pose	*posar*

Inspiration from Our World

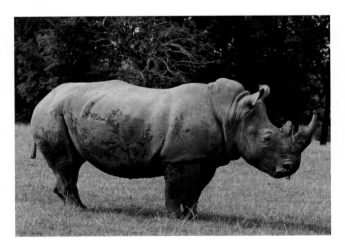

B A rhinoceros

Inspiration from Art

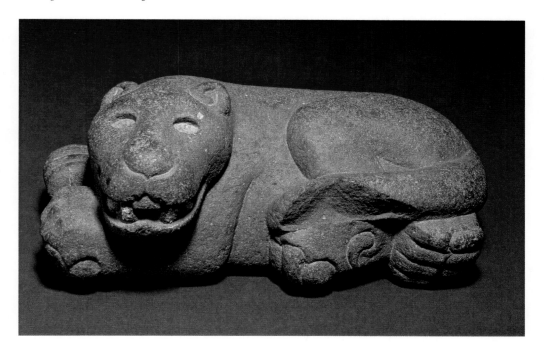

A

Aztec, *Reclining Jaguar*, 1440–1521. Stone.

This sculpture was made long ago.

What animal do you see? How do you know?

What kind of texture does the sculpture have?

 A pig

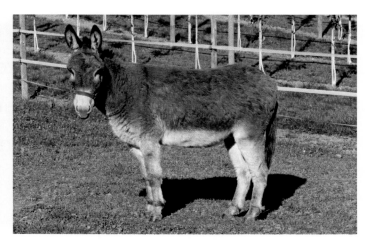

D A donkey

Step 2: Begin to Create ⟶

- How will you begin?

- What big form will you make?

Make a big form.

Step 3: Revise

- Turn your sculpture to see all sides.

- Does your sculpture look like an animal?

- Did you pose your animal?

Step 4: Add Finishing Touches

- Did you add eyes and other details to your animal?

- What other details can you add?

- What textures can you show?

Step 5: Share and Reflect

- Show your animal to your classmates.

- Talk about how the sides are different and the same.

- What do you like best about your animal?

Squeeze the neck.

Mark body into four parts.

Pinch and pull thick legs. Pose your animal.

Art Criticism

A Student artwork

Describe
What animal do you see?

Analyze
What big form did the artist use to begin?

Interpret
What does the sculpture tell about the animal?

Evaluate
Do you like this sculpture? Why?

Nature

Getting Ideas from Nature

In the Past

The painting in picture was made long, long ago.
It is the oldest painting in this book.
What animals do you see?
What colors did the artist choose?

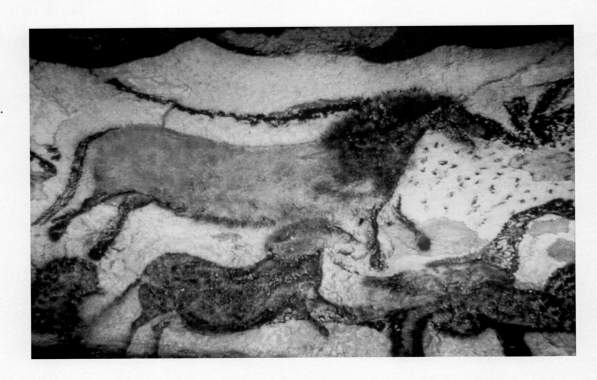

A

Prehistoric,
Herd of Horses,
ca. 15,000 BCE.
Wall painting.

In the Past

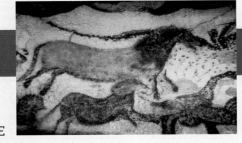

ca. 15,000 BCE

1985

In Another Place

Picture **B** shows a sculpture that was made in **Canada**. What does the sculpture show? Do you like the colors?

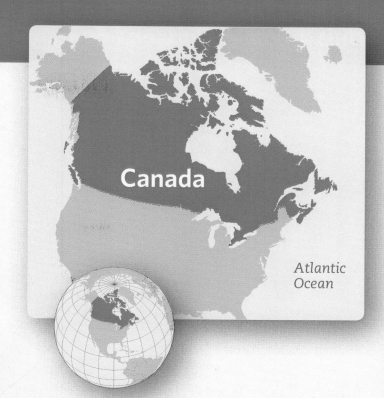

B Bill Reid, *Phyllidula—The Shape of Frogs to Come*, 1985. Wood sculpture.

In Daily Life

Some sculptors work with plants. They make topiaries. A topiary is a plant that grows on a wire frame.

In the Present

C

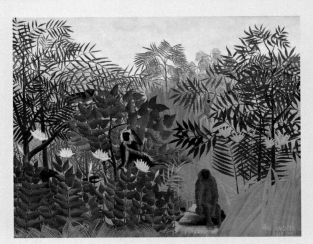

a b c

Match each phrase to a picture.

1 a pattern of repeated shapes

2 nature up close

3 a landscape

Write About Art

Look at your book.

Pick an artwork about nature.

Tell what you see.

Tell what you like.

Aesthetic Thinking

Look at the picture on the opposite page.

Why do you think the artist made this carved animal?

Do you like to make things? Why?

Why do people make things?

Art Criticism

Describe

What animal
do you see?
What is this artwork
made of?

Analyze

What colors did the
artist use?
Can you find patterns?

Interpret

What animal inspired
this artwork?
Does this animal
seem proud? Why?

Evaluate

What did the artist
do well when he made
this artwork?

A Zeny Fuentes, *Red Cat*. Wood carving.

Special Times
Art to Remember

A

William H. Johnson, *Children Playing London Bridge,* ca. 1942. Watercolor painting.

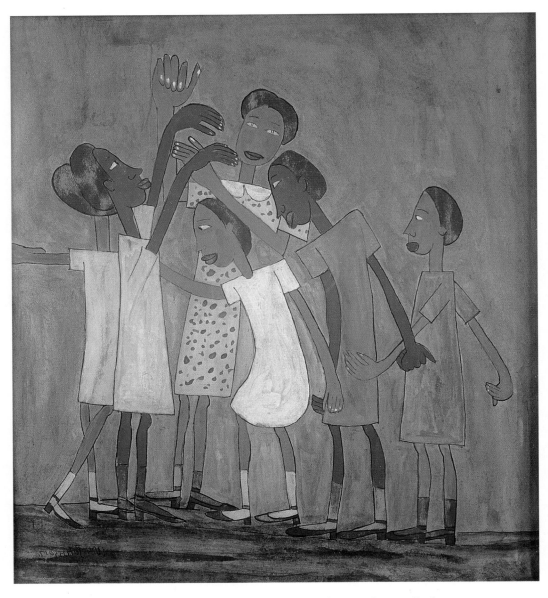

What are the children doing in this painting?

122

We all remember and celebrate special times.

Artists help us to remember.

They make artworks about the past.

What special time did the artist show in picture Ⓐ?

What did the artist show in picture Ⓑ?

You can make art to remember special times.

You can get ideas from your memory.

Where do you see patterns in this artwork?

Ⓑ William H. Johnson,
Going to Church,
ca. 1940–1941. Oil painting.

Meet William H. Johnson

William H. Johnson painted people going about their daily lives.

Then and Now

Vocabulary

English	Spanish
photograph	*fotografía*

Picture **A** is a photograph of a city.
An artist took this photograph long ago.
We can see how the city looked long ago.
What else can we learn from the photograph?

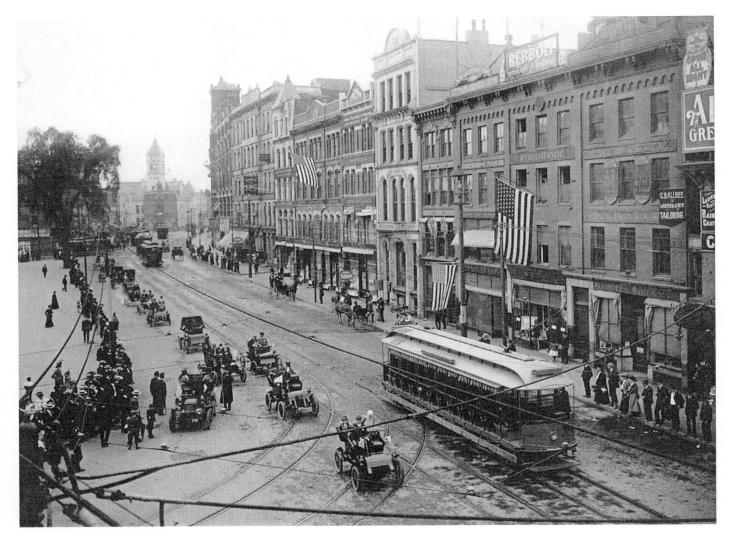

A Worcester, Massachusetts, 1903–1904.

What can we learn about the city in picture B?

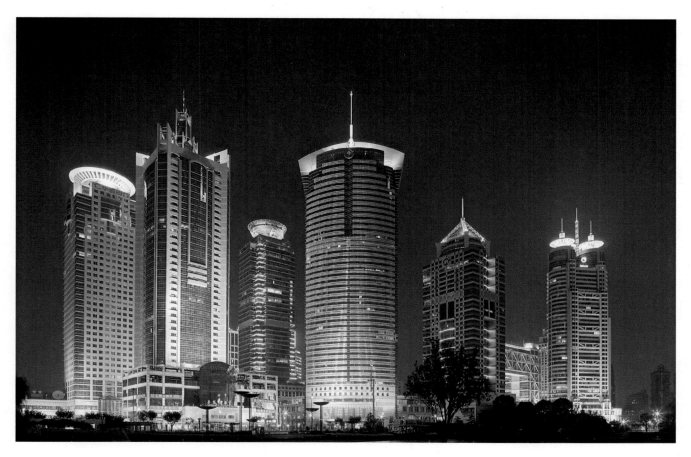

B Shanghai office buildings at night

Studio Time

Showing Your Town

Draw a picture of your town.

- Show what people do.
- What will you draw?

C Student artwork

Remember Your School

Vocabulary

English Spanish
design *diseñar*

Artists design things we use every day.
An artist designed the stamp in picture Ⓐ.
The stamp shows something from the past.
What do you see?

Artists planned the letters and the pictures.
The design is printed many times.

What did the artist design in picture Ⓑ?

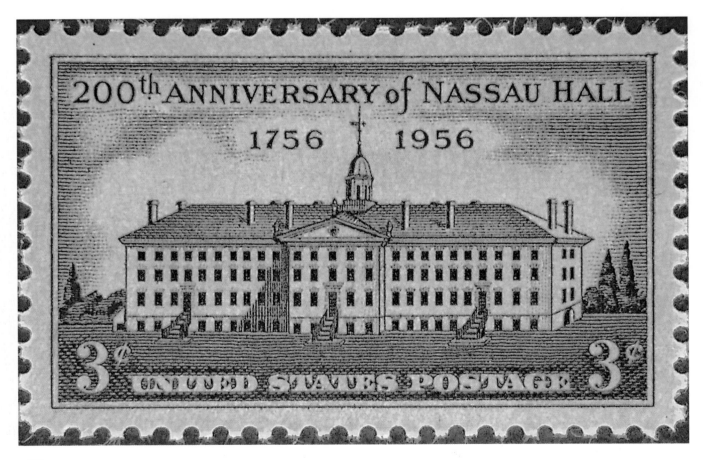

Ⓐ *Nassau Hall, 1956. Stamp.*

B *West Point*, 1937. Stamp.

A Stamp to Remember

Design a stamp.

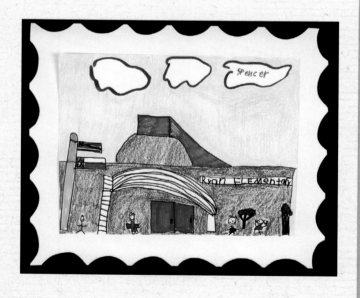

- Show something special about your school.

- Use pictures and letters.

- What will you design?

C Student artwork

Materials you will need:
- scissors
- glue
- cardboard
- heavy paper
- string, yarn, toothpicks, coins
- aluminum foil
- brushes

Big and Little Shapes

A Building to Remember

Read, Look, and Learn

Some buildings have a special design.

Some buildings help people remember the past.

You can make a picture of a special building in your town.

Use cardboard and foil.

What special buldings do you know in your town?

Remember to:

✔ Show a special building.

✔ Add details with small shapes and other materials.

Vocabulary

English	Spanish
building	*edificio*

Step 1: Plan and Practice

- Look at the pictures on these pages for ideas.
- What building will you show?
- Make some sketches of the building you want to show.

Inspiration from Our World

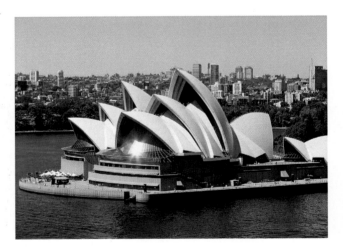

B

Inspiration from Art

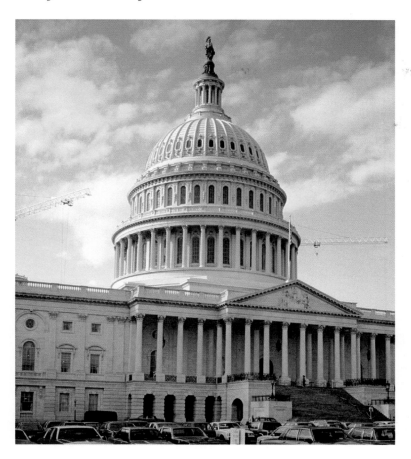

 A

Thomas U. Walter, United States Capitol, Washington, DC, 1851–1863.

This picture shows an important building for people in the United States.

Where do you see geometric shapes?

Where do you see details?

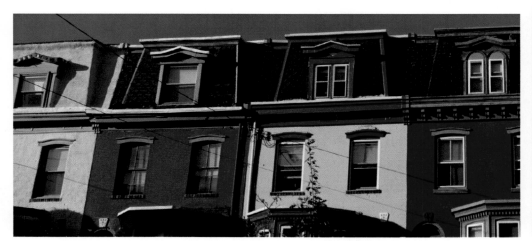

 C

 D

Step 2: Begin to Create ──────→

Cut shapes.

- Use a piece of cardboard for a base.

- What shapes will you need?

- What other materials will you add for details?

Step 3: Revise

- Does your building need more shapes?

- Have you added details?

Step 4: Add Finishing Touches

- Rub the foil over your glued shapes.

- Rub to show details.

- Fold over the foil edges.

Step 5: Share and Reflect

- Show your picture to your classmates.

- Ask if they know what building you have shown.

- What do you like most about your artwork?

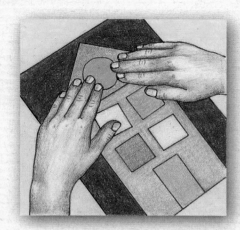
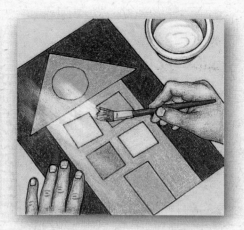
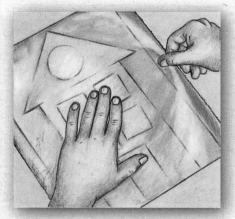

Glue them down.

Brush glue
on your work.

Press down
some foil.

Art Criticism

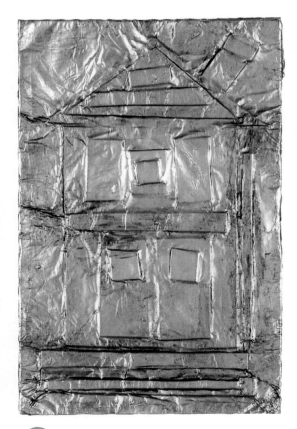

A Student artwork

Describe
What kind of building
did the artist show?

Analyze
What kinds of shapes
did the artist use?

Interpret
Does this building
seem important?

Evaluate
Do you like this
artwork? Why or why
not?

Remember Fun Times

Artists make artworks to show special times.
What fun times do you have with your family?
What fun times do you have with your friends?

What is happening in picture 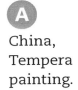?
What colors did the artist choose?

A
China,
Tempera
painting.

What do you see in picture B?
Why is this a special time?

B Doris Lee, *Thanksgiving*, ca. 1935. Oil painting.

A Good Time

You can draw a picture of special times with family or friends.

• What will you show?

• What colors will you choose?

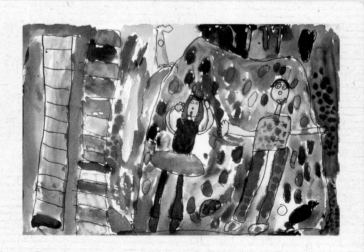

C Student artwork

Remembering Pets

What pets do you like? Why?
Artists planned their paintings about pets
in pictures **A**, **B**, and **C**.

Why do you think the artists made these paintings?
What helps you know the animals are pets?

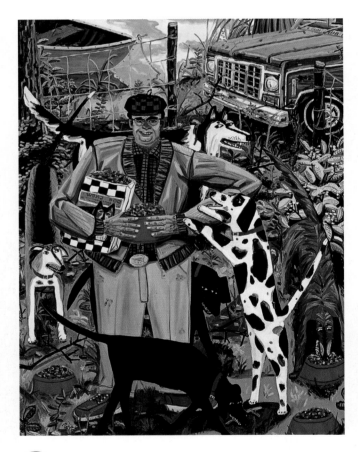

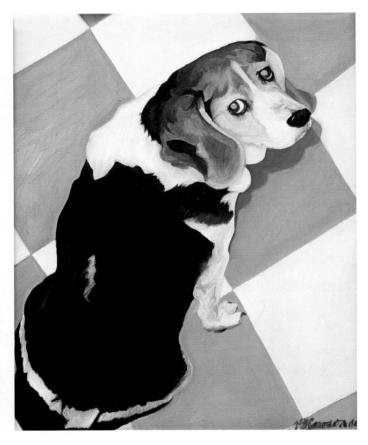

A David Bates, *Feeding Dogs*, 1986.
Oil painting.

B Gini Lawson, *Ellie*, 2005. Oil painting.

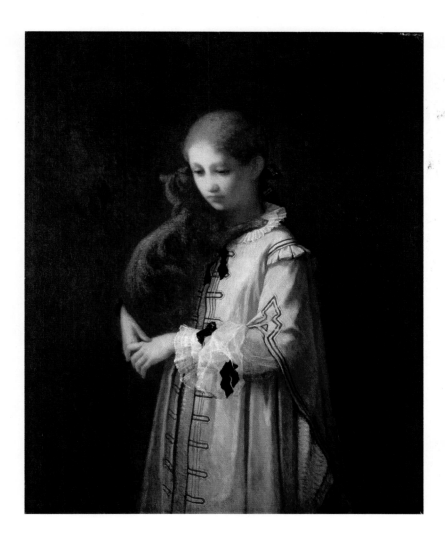

What colors and textures do you see in this painting?

C

William Morris Hunt,
Girl with Cat, 1856.
Oil painting.

Studio Time

Pet Portrait

Paint a picture about a pet that you like.

- Will your pet be standing, sitting, or playing?

- How will you plan your painting?

D Student artwork

Materials you will need:
- colored paper
- papers with patterns
- glue
- scissors

Planning a Project
A Quilt to Remember

Read, Look, and Learn

Quilts are artworks made out of cloth.

Artists plan quilts to remember special times.

People sometimes work together to make a quilt.

You can make a picture of yourself for a class quilt.

Remember to:

✔ Use cut paper for the parts of your face.

✔ Add colors and details.

Vocabulary

English	Spanish
quilt	*edredón*

Step 1: Plan and Practice

- Look at the pictures on these pages for ideas.
- How are the quilts the same?
- How are they different?
- How will you design your part of the quilt?

Inspiration from Our World

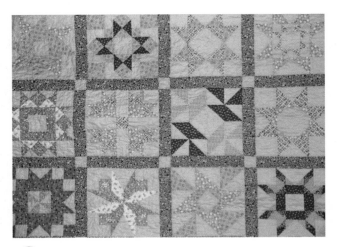

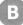

Inspiration from Art

Faith Ringgold,
Echoes of Harlem, 1980.
Painted quilt.

An artist made this quilt.

How many people did she show in this quilt?

What details did she show?

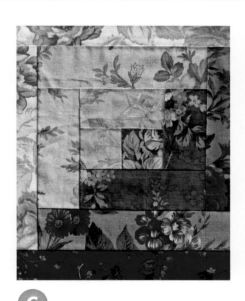

C

D

Step 2: Begin to Create ⟶

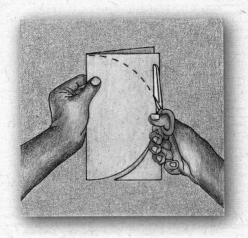

Fold paper. Cut a large shape for the face.

- Use cut-paper shapes to make your face.
- What parts of your face will you show?
- What colors will you choose?

Step 3: Revise

- Do the shapes show the parts of your face?
- Do you like the colors?

Step 4: Add Finishing Touches

- What other details can you add?
- Make sure your pieces are glued flat.

Step 5: Share and Reflect

- Show your finished picture to your classmates.
- How will your class arrange the quilt parts?
- Are you happy with your part of the quilt?

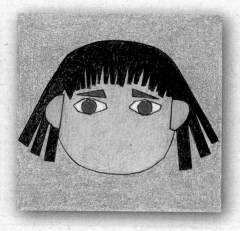
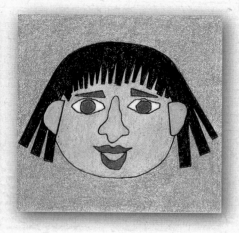

Cut other shapes for parts of face.

Arrange and glue the shapes to paper.

Add details to your quilt block.

Art Criticism

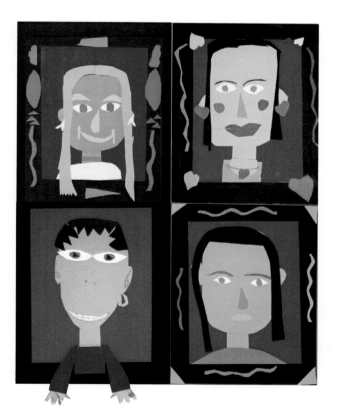

A Student artwork

Describe
What do you see in these quilt blocks?

Analyze
How are the parts arranged?

Interpret
Do these people seem happy?

Evaluate
What is special about this quilt?

Party Cakes

Vocabulary

English Spanish
decorator *decorador*

We all have ways to celebrate
special days.
Some people make cakes
for special days.

Picture Ⓐ is a print of fancy cakes.
What kinds of lines do you see?
What colors did the artist choose?
How do the colors make the cakes look special?

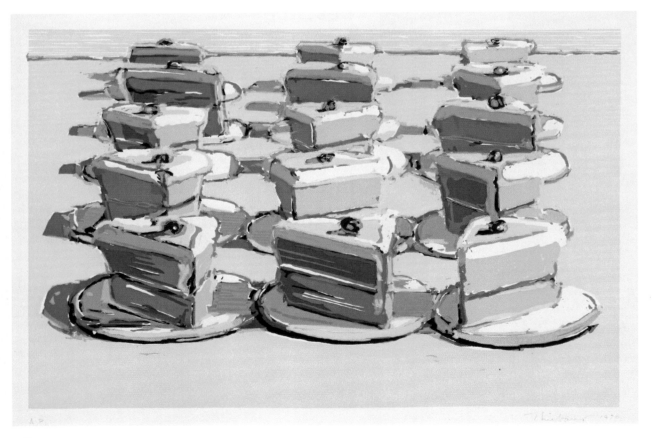

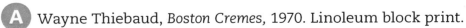

Ⓐ Wayne Thiebaud, *Boston Cremes*, 1970. Linoleum block print.

Picture **B** is a photograph of a cake made for a special time.

What kinds of lines did the cake decorator make?

What colors did she choose for her cake?

B Cake by Lisa Raffael, Delicious Desserts.

Studio Time

Fancy Cakes

Make a drawing of a very special cake.

- How big will your cake be?
- What colors will you choose?
- How will you use lines?

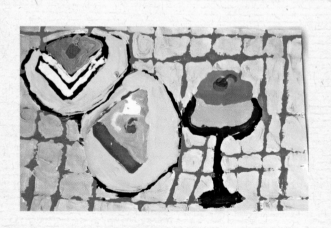

C Student artwork

Dressing for Celebration

Vocabulary

English	Spanish
festival	*festival*
costume	*vestimenta*

Some people dress up
to celebrate special times.
Picture **A** shows a boy dressed up
for a **festival** in his town.
What is he wearing?
What makes his **costume** fancy?

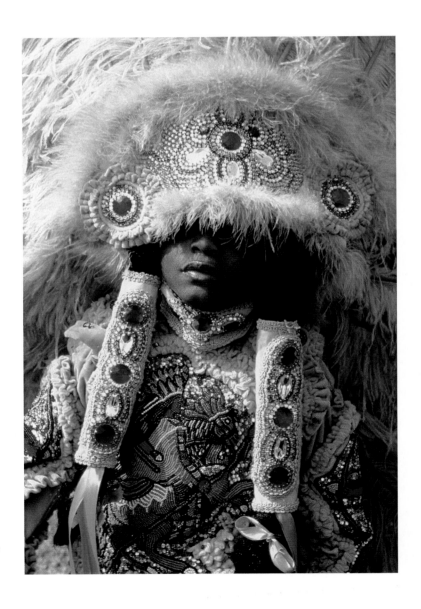

Boy dressed as a Mardi
Gras Indian, New Orleans,
Louisiana.

B School festival, Day of the Dead, Denton, Texas.

The children in picture B are dressed up as artists.

They dressed up for a special day at their school.

How did they dress up? What did they wear?

Fancy Hats

You can make a wonderful fancy hat with paper.

- Shape big pieces of paper on your head.

- Roll up the edges.

- What can you add to make it fancy?

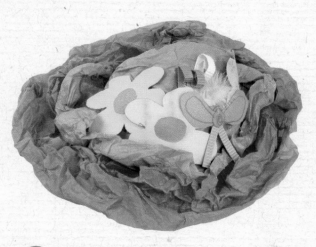

C Student artwork

Designing a Paper Mask
Celebrating with Masks

Read, Look, and Learn

There are many kinds of masks.
What masks have you seen?
Some people wear masks for special times.
You can make a mask for a special day.

Remember to:

✔ Fit your mask to your head.

✔ Add details with paper shapes and markers.

Vocabulary

English	Spanish
mask	*máscara*

Step 1: Plan and Practice

- Look at the animals in the pictures on these pages for ideas.

- What animal mask will you make?

Inspiration from Our World

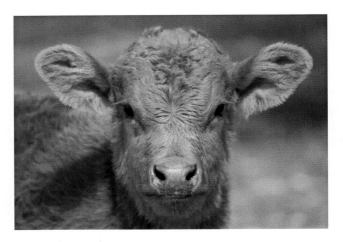

B Cow

Inspiration from Art

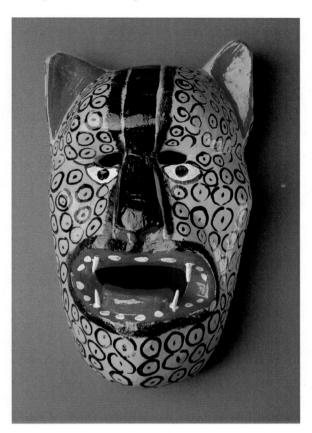

 A

Mexico, *Jaguar*. Mask.

This jaguar mask is from Mexico.

Since long ago, the jaguar mask has been worn for special days.

The person who wears the mask does a special dance.

How did the artist show details and patterns?

C Orangutan

D Lion

E Duck

Step 2: Begin to Create ──────────────▶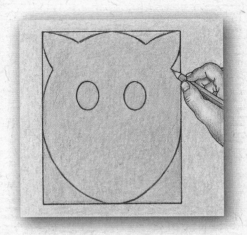

- What is the big shape for your animal mask?

- Draw the big shape.

Draw a shape for the mask.

Step 3: Revise

- Does your mask fit your head?

- Can you see through the eyes?

- What details can you add?

Step 4: Add Finishing Touches

- Add straps to tie your mask to your head.

- Are all your shapes glued?

Step 5: Share and Reflect

- Wear your mask to show your classmates.

- Is it like others in your class? How?

- Will you make another mask sometime? Why?

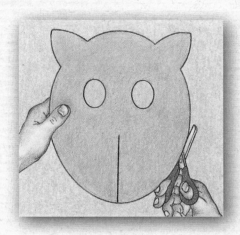
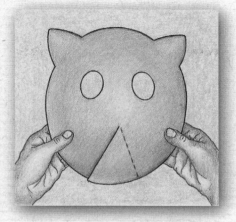
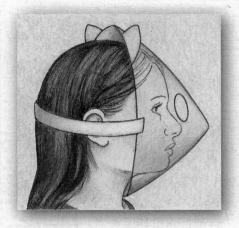

Cut out the shape.
Cut the bottom.

Overlap the paper.
Glue it down.

Add cut-paper
shapes for details.

Art Criticism

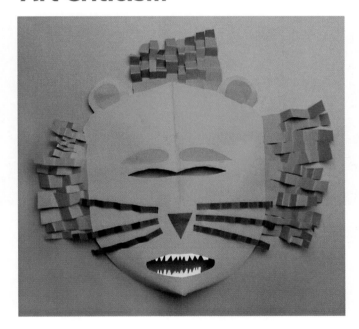

A Student artwork

Describe
What animal does the
mask show?

Analyze
What details did the
artist add?

Interpret
Does the mask seem quiet?
Loud? Sad? Happy? Why?

Evaluate
Why is this mask special?

Special Times
Fun and Games

In the Past

The painting in 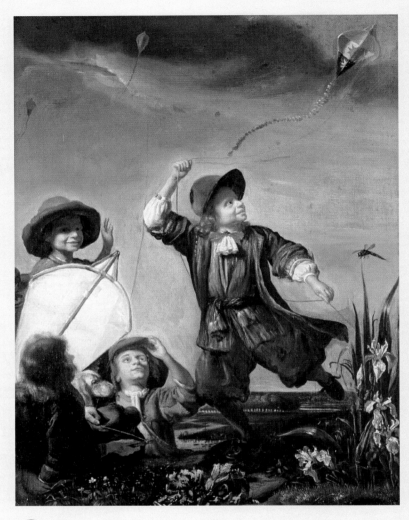 **A** was made many years ago. How can you tell? What are the children doing?

A Godfried Schalcken, *Boys Flying Kites*, ca. 1670. Oil painting.

In the Past

ca. 1670

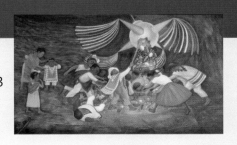

1953

In Another Place

Picture **B** is a painting about children in **Mexico**. The artist wanted to show a special time. What do you think is happening?

Gulf of Mexico

Mexico

Pacific Ocean

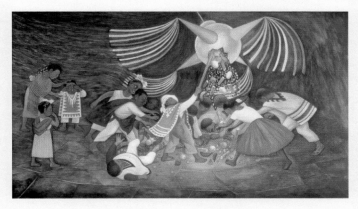

B

Diego Rivera, *La Piñata*, 1953. Mural.

In Daily Life

Some people use their special skills to decorate cakes. What special times do you celebrate with cakes?

In the Present

C

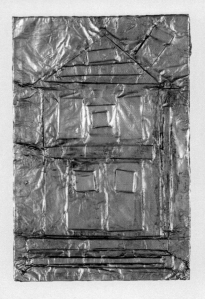

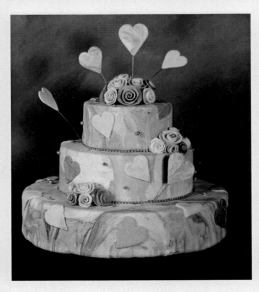

a b c

Match each phrase to a picture.

1 something used to celebrate a special day

2 a part of a quilt

3 an artwork showing a special building

Write About Art

Look at the picture on the opposite page.

What did the artist show?

What is the first part you see? Why?

Aesthetic Thinking

How is a cake decorator like an artist who paints?

Art Criticism

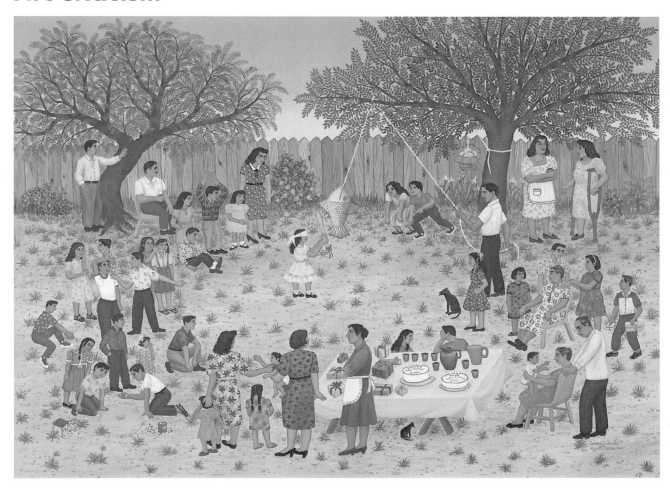

A Carmen Lomas Garza, *Cumpleaños de Lala y Tudi*, 1989. Oil painting.

Describe

What do you see?

Analyze

How are the people placed in the picture?

Interpret

Does this seem like a special time? Why?

Evaluate

What did the artist do really well in this artwork?

Change
New and Different

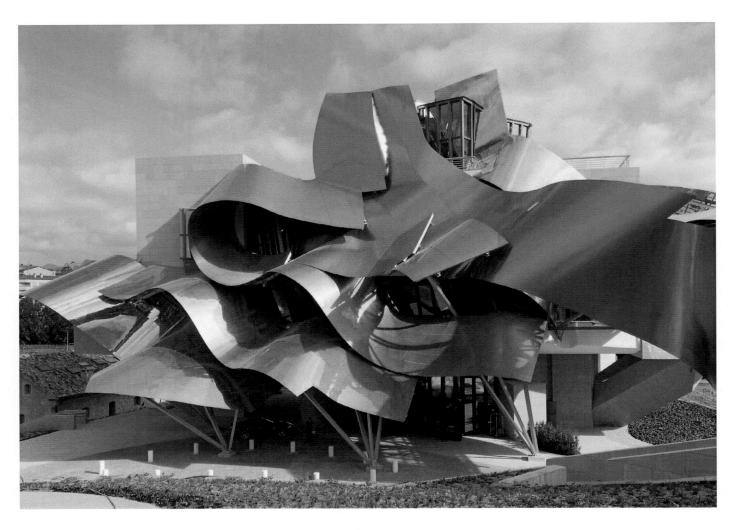

A Frank Gehry, Hotel Marques de Riscal Elciego, Alava, Spain, 2006.

Where do you see wavy lines?

Every day we see new and different things.
The buildings in **A** and **B** are new.
An architect designed them.

Do they look different from other buildings you have seen?
Artists make artworks that show changes in our world.
You can think and work like an artist.

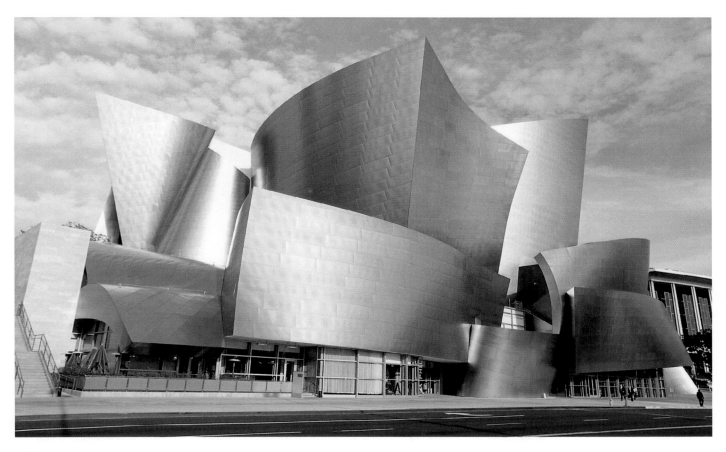

B Frank Gehry, Walt Disney Concert Hall, Los Angeles, 2003.

Where do you see curves?

Meet Frank Gehry
Frank Gehry is an architect who designs buildings.

Changing Seasons

Vocabulary

English	Spanish
contrast	*contraste*

Some artists paint pictures about seasons.

Snow covers the ground in picture **A** .
The dark bridge stands out against the light snow.
This is called contrast.

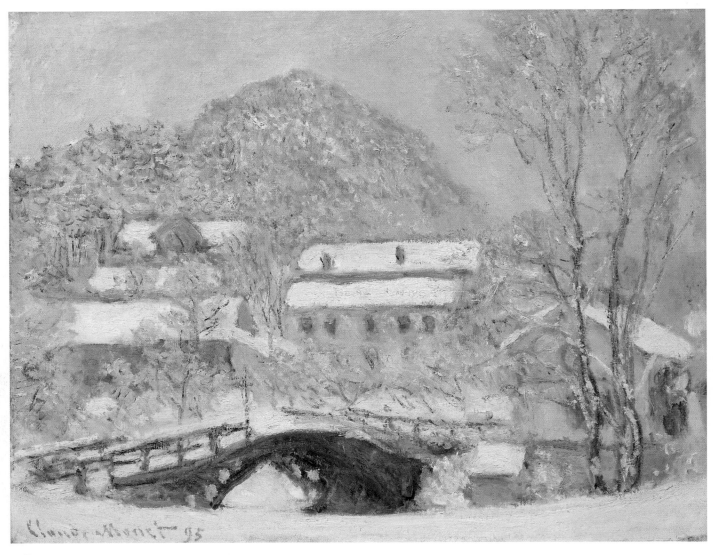

A Claude Monet, *Sandvika, Norway,* 1895. Oil painting.

How does the artist show an autumn scene
in picture **B**? What stands out?

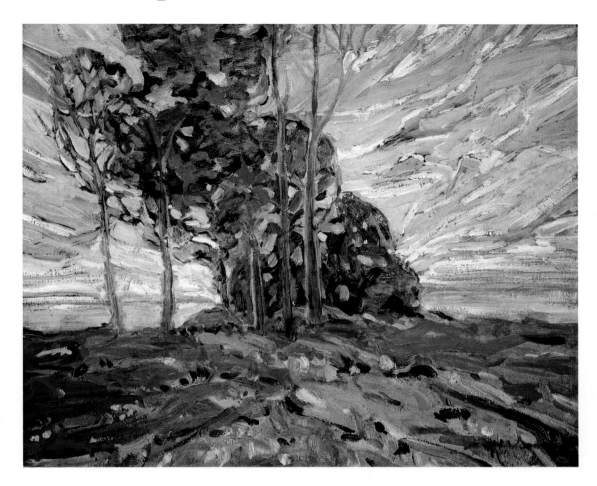

B

Hale Woodruff,
Twilight, 1926.
Oil painting.

Studio Time

A Favorite Season

Make a picture about your
favorite season.

- What season will you show?
- What colors will you choose?
- What will stand out?

C Student artwork

Day and Night

How does the sky look during the day?
How does it change at night?

Artists can show how things look during the day.
They can show how things look at night.

Picture Ⓐ shows some people playing golf during the day.

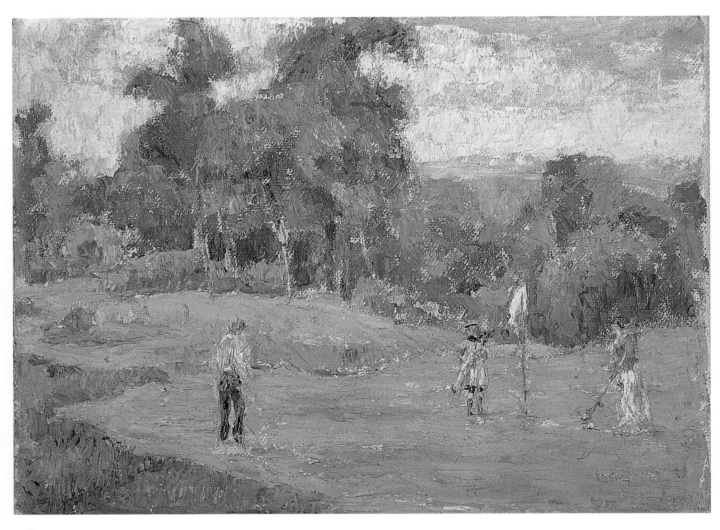

Ⓐ Marjorie Phillips, *Golf at St. Cloud*, ca. 1924. Oil painting.

In picture **B**, the artist painted a baseball game at night. How did she show day and night?

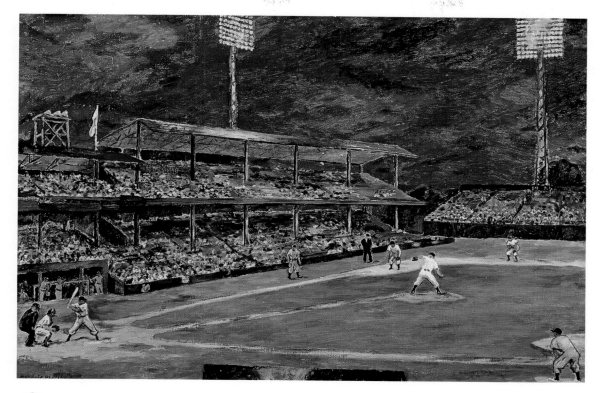

B Marjorie Phillips, *Night Baseball,* 1951. Oil painting.

Studio Time

Time at Night

You can show change from
day to night.
Draw with crayons on white paper.

- Use colors that show daytime.

- Brush over your drawing with paint.

- Choose a color for night.

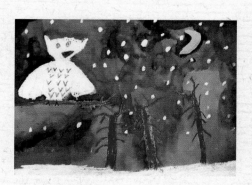

C Student artwork

Materials you will need:
- paper
- scissors
- glue
- pencils, crayons, or markers

Differences in Shapes
Changes over Time

Read, Look, and Learn

Where do butterflies come from?

How does a tadpole grow into a frog?

Artists can show nature's changes.

How can you show nature's changes?

Remember to:

✔ Plan your artwork to show changes in nature.

✔ Create a background with cut-paper shapes.

✔ Cut smaller shapes for each step of the change.

Step 1: Plan and Practice

- Look at the pictures on these pages for ideas about changes in nature.

- What will you show?

- Make some practice drawings to show how things change.

Vocabulary

English	Spanish
background	*fondo*

Inspiration from Our World

Ⓑ

Inspiration from Art

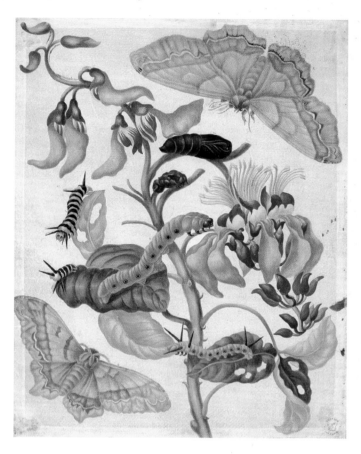

Maria Sibylla Merian,
Life Cycles of Two Moths, 1705.
Watercolor illustration.

The artist who painted this artwork studied nature very closely.

She liked to show the changes in moths, butterflies, and frogs.

What do you know about the life of a moth?

C

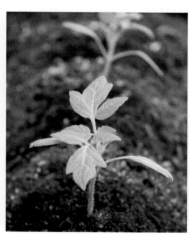

D

Step 2: Begin to Create ⟶

Fold paper to make four equal sections.

- Choose colored papers for your background.
- Cut large shapes to show plants in the ground or water.

Step 3: Revise

- Does your artwork show a change in nature?
- Did you use shapes to show changes?

Step 4: Add Finishing Touches

- What details will make the changes show up better?
- What else does your background need?

Step 5: Share and Reflect

- Share your finished artwork with your classmates.
- Find an artwork that is very different from yours.

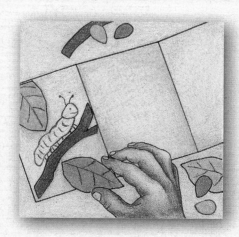

Create a background with cut-paper shapes.

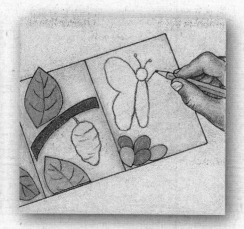

Draw each step of the change you want to show.

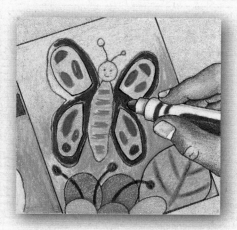

Add details with small shapes and markers.

Art Criticism

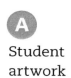

Student artwork

Describe

What changes in nature does this artwork show?

Analyze

What did the artist keep the same?

What did the artist change?

Interpret

Does the change seem to go quickly or take a long time?

Evaluate

What did the artist do really well in this artwork?

Dressing Up

These portraits show how kings and queens dressed in the past.
They dressed up to have their pictures painted.
Do people dress like this today?

What little shapes
do you see in picture **A**?
What big shapes
do you see?

Where are colors
repeated in picture **B**?
Where do you see
patterns in picture **C**?

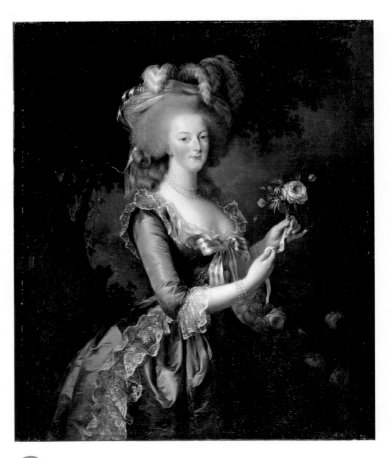

A Louise Elizabeth Vigée-LeBrun,
Marie Antoinette, 1783. Oil painting.

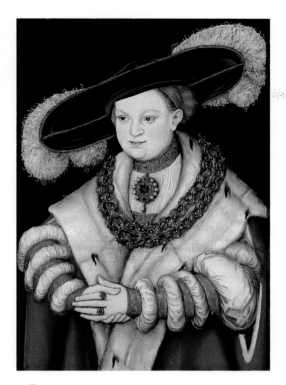

B Lucas Cranach (the Elder), *Portrait of Hedwig, Margravine of Brandenburg-Ansbach*, 1529. Oil painting.

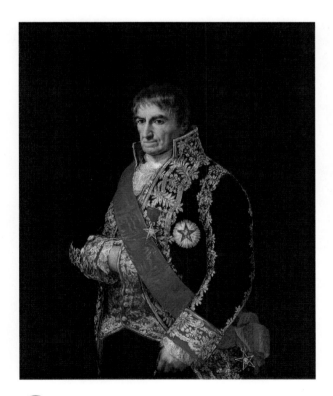

C Francisco Goya, *Portrait of General José Manuel Romero*, 1810. Oil painting.

Picture Time

You can show yourself dressed up to have your picture taken.

- What special clothes will you wear?
- How can you add pattern to your picture?

D Student artwork

Vocabulary

English Spanish

variety *variedad*

Dressing for Play

When an artist uses many different lines, shapes, or colors in an artwork, it is called **variety**.

What parts are the same in picture 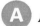?
What parts are different?

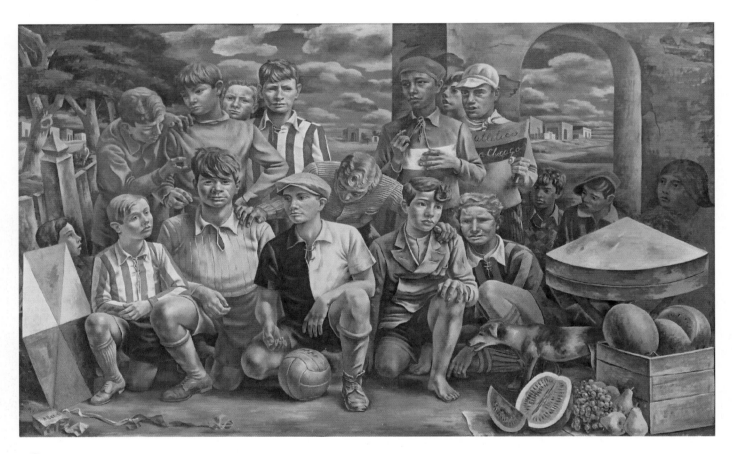

A Antonio Berni, *New Chicago Athletic Club*, 1937. Oil painting.

What game are the people playing in picture B?
What shapes and colors stand out?

B

Winslow Homer, *Croquet Scene*, 1866. Oil painting.

Studio Time

Play Clothes

Draw a picture of people playing a game we play today.

C

Student artwork

- What game will you show?

- What colors will you choose?

- How will you make the people stand out?

Creating with Paper
Dressing Up and Down Puppet

Materials you will need:
- paper
- crayons or markers
- scissors
- glue
- craft stick or drinking straw

Read, Look, and Learn

We wear different clothes for different times.
You can show changes in how you dress.
Make a puppet with two sides.

Remember to:

✔ Draw yourself dressed two ways.

✔ Fill your paper with your drawing.

✔ Add details.

Step 1: Plan and Practice

- Look at the pictures on these pages for ideas.

- What two ways will you show yourself?

Vocabulary

English	Spanish
puppet	*marioneta*

Inspiration from Our World

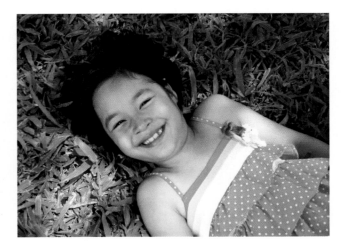

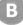

Inspiration from Art

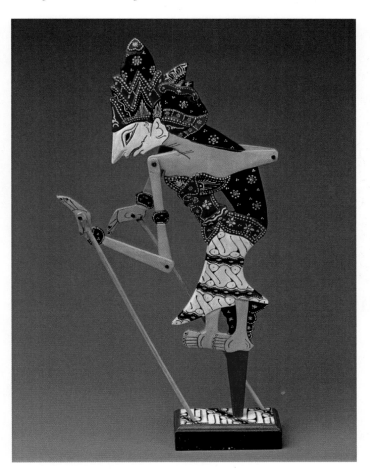

A

Indonesia, Shadow puppet.

This shadow puppet is made out of wood.

It has moving parts. Can you see how it moves?

Where do you see patterns?

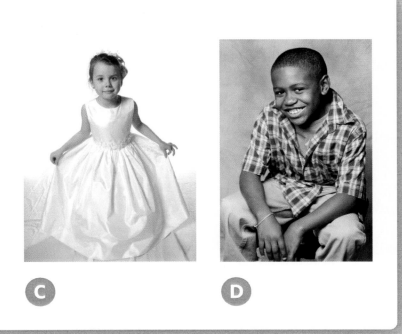

C D

Step 2: Begin to Create ——————→

- What clothes will you show?

- What details will show the different ways you dress?

Draw yourself
in play clothes.

Step 3: Revise

- Do the front and back look different?

- What can you add?

Step 4: Add Finishing Touches

- Glue the two sides of your puppet together on a stick.

- Are your puppet sides glued together all around?

Step 5: Share and Reflect

- Use your puppet to tell about when you were dressed up.

- Tell about a time when you were dressed differently.

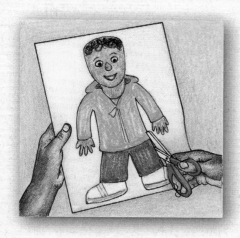

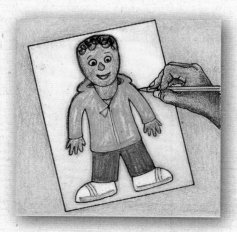

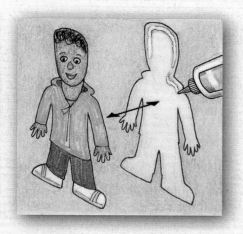

Cut out your shape.

Trace shape onto another paper. Cut out second shape.

Draw yourself dressed up. Glue shapes together.

Art Criticism

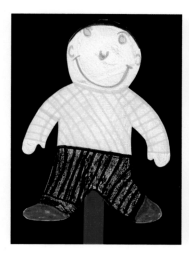

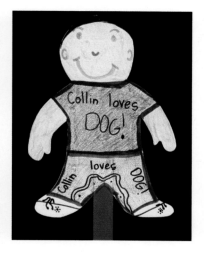

A Student artwork

Describe
What clothing is shown on each side?

Analyze
What colors and patterns do you see?

Interpret
How did the artist show changes?

Evaluate
What did the artist do really well?

Furniture for the Future

Artists design things we use.
They plan the lines, colors, and forms.

Look at these chairs.
What colors do you see in picture (A)?

What kind of lines and shapes do you see in picture (B)?
Describe the lines you see in picture (C).

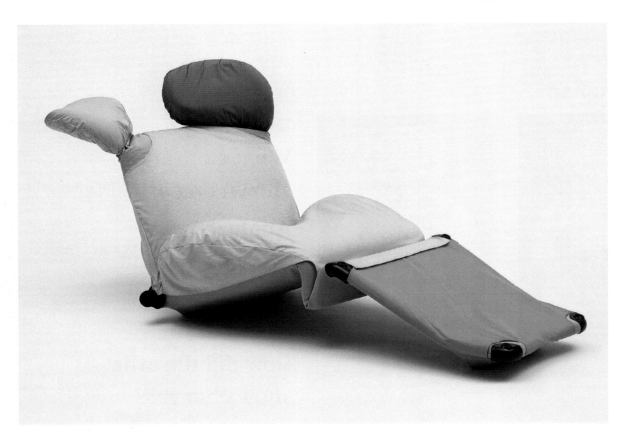

(A) Toshiyuki Kita, *Wink Lounge Chair,* 1980.

B Frank Gehry, *Easy Edges Side Chair,* 1972.

C Gerrit Rietveld, *Zig-Zag Chair,* 1934.

Fun Furniture

You can design a chair. Use paper shapes and strips.

- Practice folding, curling, and cutting paper.
- Combine parts to make fun furniture.
- Use glue and tape.

D Student artwork

A Way to Travel

Vocabulary

English	Spanish
vehicle	*vehículo*

Artists design many things.
Some artists design things for the future.

How is the car in picture **A** different from other cars?
Do you like this car?

A Micro Compact Car Smart GmbH, 1998.

What lines and shapes do you see in picture B ?

Why is it called *Flying Object?*

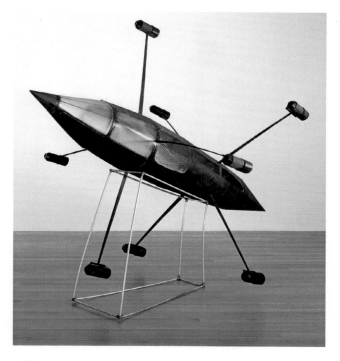

B Panamarenko, *Flying Object (Rocket)*, 1969. Assemblage.

Future Travel

Design a vehicle for the future.

It can travel on land, under water, or in the air.

- Make a collage to show your idea.
- Cut shapes from paper.
- Glue them on big paper.
- Add details with markers or crayons.

C Student artworks

Designing a Robot
Work in the Future

Read, Look, and Learn

Robots are machines.

People design them to do jobs.

You can make a model for a robot.

What job will it do?

Remember to:

✔ Add small parts to show how it works.

✔ Add colors and lines for details and pattern.

Step 1: Plan and Practice

- Look at the robots in the pictures on these pages.

- What do you want your robot to do?

Inspiration from Our World

Inspiration from Art

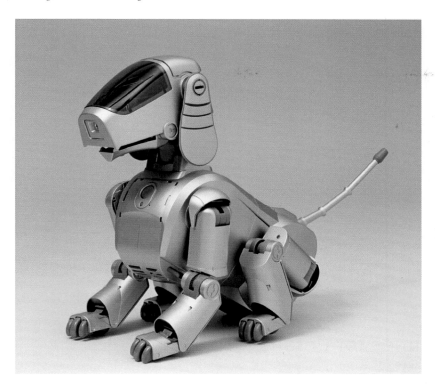

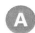

Sony Corporation and Hajime Sorayama, *AIBO Entertainment Robot (ERS-110)*, 1999.

An artist designed this robot.

He first made a painting to show how it would look.

It is a pet dog that can do tricks.

C

D

Step 2: Begin to Create

• Use a large piece of cardboard for a base.

• Place your robot parts on the cardboard.

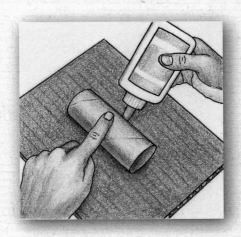

Glue found objects to cardboard base.

Step 3: Revise

• What small parts will show how your robot works?

• Did you add colors and lines for details and pattern?

Step 4: Add Finishing Touches

• Make sure your robot parts are in the right place.

• Then glue them down.

• Glue big objects first, then smaller ones.

Step 5: Share and Reflect

• Display your finished work.

• Write a story about your robot.

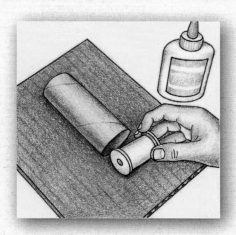

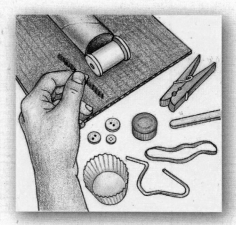

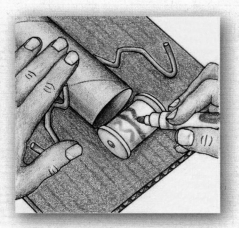

Add materials that will help your robot do its job.

Add materials. Show how your robot will see and talk.

Use markers and paint to add color and details.

Art Criticism

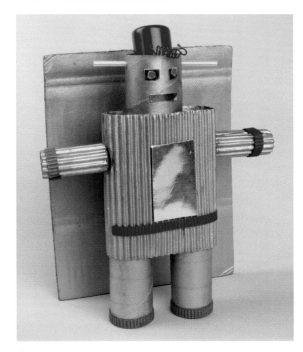

A Student artwork

Describe
What materials were used to make this robot?

Analyze
How are the parts put together?

Interpret
Does this look like a friendly robot? Why, or why not?

Evaluate
What makes this robot special?

Change
Things That Change

In the Past

Picture shows a whirligig.
Whirligigs are sculptures that move and change.
What makes them move?

A

Jack Mongillo,
*Whirligig, Man on
Bicycle,* ca. 1940.

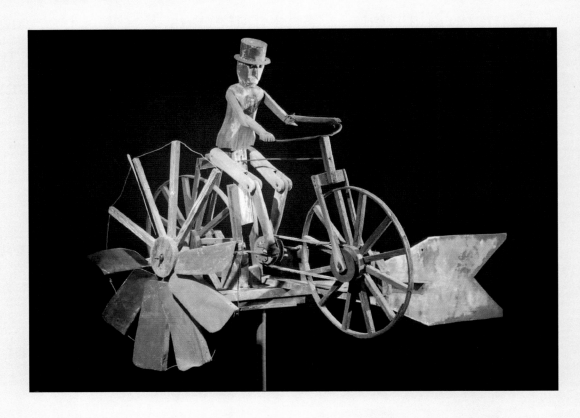

In the Past

1940

1961

178

Norwegian Sea

Scandinavia

Sweden

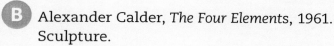
B Alexander Calder, *The Four Elements*, 1961. Sculpture.

In Another Place

Picture **B** shows a building in **Sweden**. It is a museum for new kinds of art. The sculptures in front of the building move and change in the wind.

In Daily Life

Kites fly in the wind.
Do you like to fly kites?
Did you know that
artists make kites?

In the Present

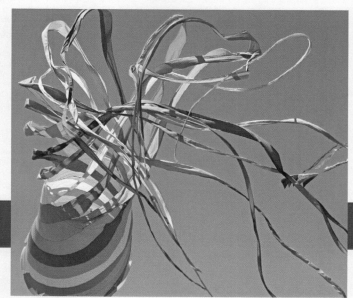

C Kites

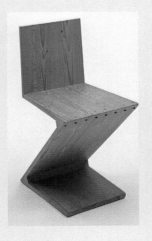

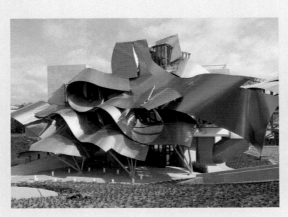

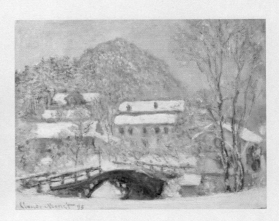

a

b

c

Match each phrase to a picture.

1 a change of season in nature

2 a design for new furniture

3 new architecture

Write About Art

If you could be a king or queen, like the people shown in Lesson 33, how would you feel?

Would you like to be a king or queen?

What would you want to change in your land?

Aesthetic Thinking

Can machines make art?

Art Criticism

Describe

What is happening in this picture?

Analyze

Does this seem like a rainbow? Why?

Interpret

How would it feel to be at this event?

Evaluate

Is this a good fireworks display?

A Cai Guo Qiang, *Transient Rainbow*, 2002. Digital photograph.

Art Safety

Study the pictures on these pages to learn safety rules. Listen for other rules and instructions your teacher may give you.

1 Use tools with sharp points and edges carefully. Keep art materials away from your eyes, mouth, and face.

2 The labels on your art materials should say "nontoxic." Nontoxic means the materials are safe to use.

3 After art lessons, wash paint, clay, glue, and other materials from your hands.

4 If you spill something, help to clean it up. If a floor is wet, people can slip and fall.

You Can Help

Study the pictures to learn how to help.
What other things can you do to help?

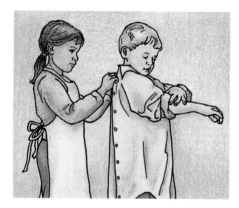

1 Help everyone get ready for art.

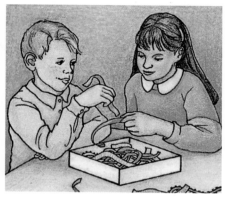

2 Share materials. Save things you can use again.

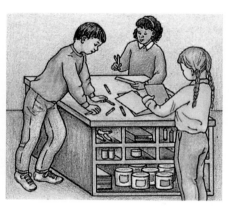

3 Help to clean up and put art materials away.

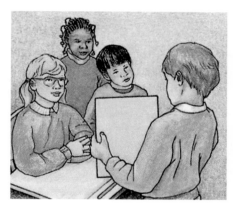

4 Listen and think about what people say.

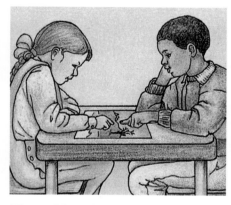

5 Talk about what you learn. Share what you know.

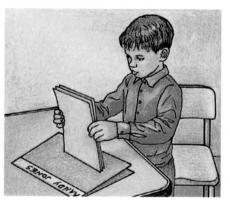

6 Save your art so you can see what you have learned.

Elements of Art
Line

Horizontal

Vertical

Diagonal

Curved

Zigzag

Dotted

Dashed

Thin

Thick

Elements of Art
Shape and Form

Geometric shapes

Circle Triangle Square Rectangle

Free-form shapes

Geometric forms

Sphere Pyramid Cube Cone

Elements of Art
Texture

Look at the textures in this picture.

Margaret Burroughs, *The Folk Singer—Big Bill*, 1996. Block print.

What looks smooth and silky in this picture?

Martin Johnson Heade, *Giant Magnolias on a Blue Velvet Cloth*, ca. 1890. Oil painting.

Elements of Art
Color and Value

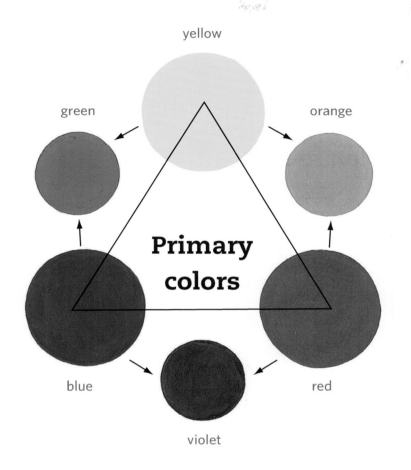

yellow

green

orange

Primary colors

blue

red

violet

Secondary colors are made by mixing two primary colors.

● + ○ = ● orange

● + ● = ● violet

○ + ● = ● green

Darkest value Lightest value

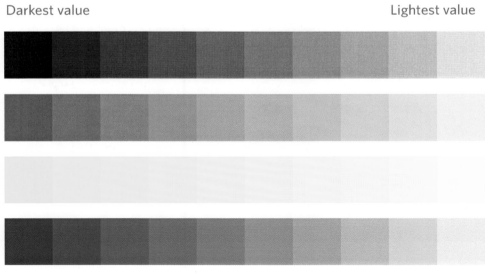

Value

Elements of Art
Space

Artists plan how they organize the space in a composition.

Close objects and people are near the bottom.

Far away objects and people are near the top.

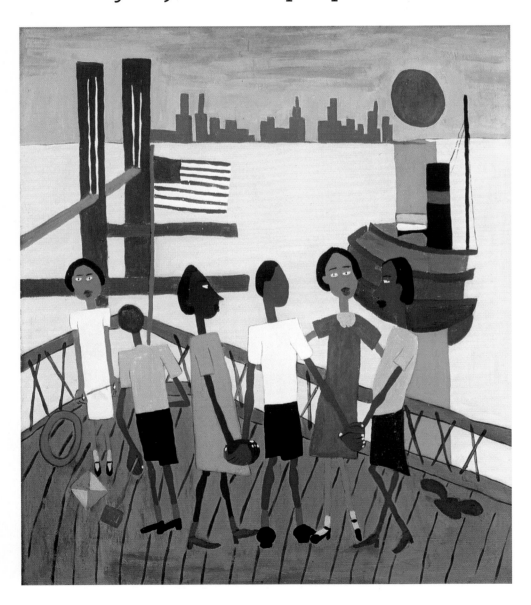

William H. Johnson, *Ferry Boat Trip*, ca. 1943–1944. Oil painting.

Principles of Design
Pattern

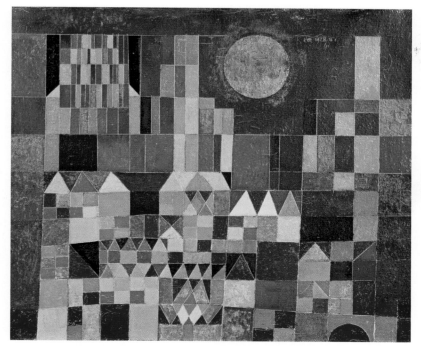

Paul Klee, *Castle and Sun*, 1928. Oil painting.

A pattern of shapes

A pattern of colors

A pattern of lines that look like textures.

Movement and Rhythm

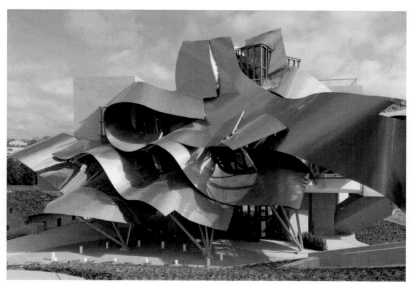

Frank Gehry, Hotel Marques de Riscal Elciego, Spain.

This building shows movement and rhythm. Look at the free-form shapes and wavy lines.

Principles of Design
Variety and Unity

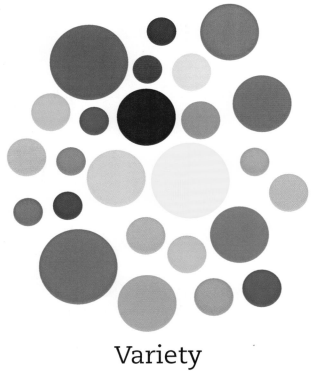

Variety

Unity

Balance

Picture Glossary

alphabet book *libro alfabético*

page 110

A book designed by an artist who includes pictures to illustrate the letters of the alphabet.

architect *arquitecto*

page 52

An artist who plans and makes buildings.

background *fondo*

page 158

The part of an artwork that appears to be in the distance or behind other objects.

building *edificio*

page 128

A structure, such as a house, barn, factory, or castle, with a roof and walls.

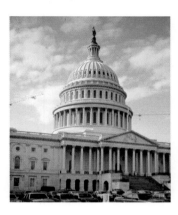

collage *collage*

page 13

An artwork made by gluing paper shapes to a flat surface.

contrast *contraste*

page 154

A large difference between two things in an artwork, such as light and dark.

cool colors *colores frescos*

page 73

Colors such as green, blue, and violet that make you think of cool places, things, or feelings.

costume *vestimenta*

page 142

Clothes worn to show a certain time in history, to celebrate a special tradition, or to create the appearance of a particular person.

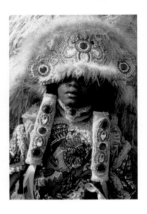

dab *toque*

page 97

Applying paint or other medium to a surface by gently tapping it with a brush or sponge.

decorator *decorador*

page 141

A person who decorates objects for special occasions or who decorates the interior spaces of homes and offices.

design *deseñar*

page 126

A plan for arranging the parts of an artwork.

expression *expresión*

page 38

The way a person's face shows feelings such as happiness, sadness, surprise, or excitement.

festival *festival*

page 142

A time of celebration.

form *forma*

page 54

A shape that has height, width, and depth.

Sphere Pyramid Cube Cone

frame *marco*

page 82

One part of an artwork that tells a story in several parts.

free-form *forma libre*

page 14

Describes shapes that have uneven outlines.

geometric *geométrico*

page 12

A shape or form with straight or perfectly curved edges, such as a square, circle, rectangle, oval, or triangle.

illustrate *ilustrar*

page 80

Creating pictures that tell a story or decorate a book or magazine.

landscape *paisaje*

page 105

An artwork that shows scenes of nature, such as mountains, valleys, fields, rivers, and lakes.

line *línea*

page 4

A mark that can be short or long, as well as thick, thin, straight, wavy, or zigzag.

mask *máscara*

page 144

An artwork that covers the face.

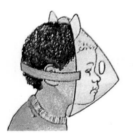 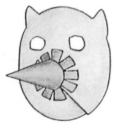

model *modelo*

page 54

A small form used to plan a building or product.

pattern *marioneta*

page 22

A repeated line, shape, or color.

photograph *fotografía*

page 124

A picture made with a camera.

pinch *pellizcar*

page 114

To squeeze or pull something between the thumb and finger.

portrait *retrato*
page 36
A picture of a person or people.

primary colors *colores primarios*
page 64
Red, yellow, and blue.

print *impresión*
page 7
An artwork made by pressing an object covered with paint or ink onto paper or another flat surface.

puppet *marioneta*
page 166
A small figure of a person or animal, made of cloth or wood, with movable parts.

quilt *edredón*
page 136
An artwork made by stitching together two layers of fabric with a layer of padding in between.

sculpture *escultura*
page 43
An artwork that you can look at from all sides.

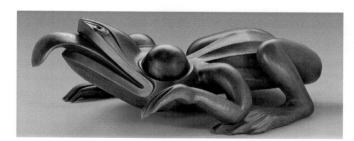

secondary colors *colores secundarios*

page 64

Colors such as orange, green, and violet that are made by mixing primary colors.

self-portrait *autorretrato*

page 36

A picture you make of yourself.

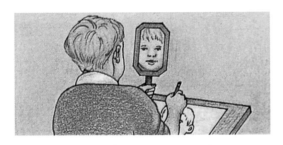

setting *escenario*

page 66

The time and place that an artwork shows.

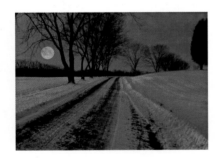

shade *sombra*

page 75

A dark color made by mixing black with another color.

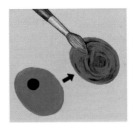

shape *forma*

page 6

A line whose ends meet to make a closed space.

Circle Triangle Square Rectangle

slab *losa*

page 24

A thick, even slice of a material such as clay, stone, or wood.

symmetry *simetría*

page 94

When the parts of an artwork are arranged the same way on the left and right sides.

texture *textura*

page 20

The way something feels.

tint *tono*

page 75

A light color made by mixing white with another color.

variety *variedad*

page 164

When an artist uses many different lines, shapes, and colors in an artwork.

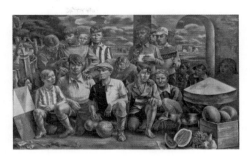

vehicle *vehículo*

page 173

A machine like a car, truck, or bus that people use to travel.

warm colors *colores cálidos*

page 72

Colors such as red, yellow, and orange that make you think of warm places, things, or feelings.

Credits

Title page: Carmen Lomas Garza, *Cumpleaños de Lala y Tudi (Lala and Tudi's birthday party)*, 1989. Oil on canvas, 36" x 48" (91.44 x 121.92 cm). Courtesy of the artist. ii: Mogolion (Casas Grandes style), Macaw Bowl, Tardio Period, 1300-1350. Earthenware with polychrome slip painting, 5 1/4" x 8" x 6 1/4" (13.3 x 20.3 x 15.9 cm). Museum of Fine Arts, Houston (Gift of Miss Ima Hogg). Susan J. Geissler, Puddle Jumper, 2005. Sculpture. Courtesy of the artist. iii: Alexander Calder, Bird Pull Toy, ©ARS, NY, 1951. Brass wire, lead, coffee can, spring. Private collection. Photo: Art Resource, NY. ©2007 Estate of Alexander Calder/ARS, NY. iv: Fernando Castillo, Portrait of Ernestina, 1937. Oil on canvas, 23 1/2" x 19 1/2" (59.7 x 49.5 cm). Private Collection. Art Resource, NY. v: Paul Klee, Castle and Sun, 1928. Oil on canvas. Private collection, Great Britain. Erich Lessing/Art Resource, NY. Paul Klee Art ©2007 ARS, NY/VG Bild-Kunst, Bonn. Jan Brett, from Jan Brett's The Mitten, 1989. Watercolor illustration. ©1989 Penguin Young Readers Group, NY. vi: Suzanne Duranceau, Beetle, 2007. Pencil and acrylic painting. ©2007. Suzanne Duranceau. David Hockney, Garrowby Hill, 1998. Oil on canvas, 60" x 76" (152.4 x 193 cm). Museum of Fine Arts, Boston. viii: Micro Compact Car Smart GmbH, company design. (German and French, founded 1994). Smart Car ("Smart & Pulse" Coupé). 1998. Steel frame and thermoplastic body panels, 61" x 59 3/8" x 8' 2 3/8" (154.9 x 150.8 x 249.9 cm). Manufactured by Micro Compact Car Smart GmbH, Renningen, Germany, and Hambach, France. Gift of the manufacturer, a company of the DaimlerChrysler Group. Museum of Modern Art, New York, NY, U.S.A. Digital Image ©The Museum of Modern Art/Licensed by SCALA/Art Resource, NY. ix: Wayne Thiebaud, Boston Cremes, from the portfolio Seven Still Lifes and a Silver Landscape, 1970, published 1971. Linoleum cut printed in color on paper, 13 7/8" x 20 1/2" (35 x 52 cm). ©The Museum of Modern Art/Licensed by SCALA/Art Resource, NY. x: Berthe Morisot, Girl in a Boat with Geese, ca. 1889. Oil on canvas, 25 3/4" x 21 1/2" (65.4 x 54.6 cm). Ailsa Mellon Bruce Collection. ©2007 Board of Trustees, National Gallery of Art, Washington, DC. Susan J. Geissler, Puddle Jumper, 2005. Sculpture. Courtesy of the artist. Charles Bulfinch, Church of Christ, 1816. Lancaster, MA. Photo credit: Steve Dunwell. xi: Young Mardi Gras Indian, New Orleans, Louisiana, U.S.A., 1989. Syndey Byrd. Two Inca ponchos with geometric designs, worn by people of high status, ca. 1380–1520. South America, South Coast, Peru, Inca Culture. Ethnologisches Museum, Staatliche Museen zu Berlin, Berlin. Werner Forman/Art Resource, NY. Toshiyuki Kita, Wink Lounge Chair (model 111.01), 1980. Polyurethane foam, steel, and Dacron, Overall (upright): 40 5/8" x 33" x 31 5/8" (103.2 x 83.8 x 80.3 cm) seat h. 14 3/4" (37.5 cm); (reclining): 24 3/8" x 33" x 75 3/4" (61.9 x 83.8 x 192.4 cm). Manufactured by Cassina, S.p.A., Milan. Gift of Atelier International Ltd. (SC21.1981.a-g) The Museum of Modern Art, New York, NY, U.S.A. Photo credit : Digital Image © The Museum of Modern Art/Licensed by SCALA/Art Resource, NY. xii: Faith Ringgold, Tar Beach 2, 1990. Silk quilt, 68" x 64" (172.72 x 162.56 cm). Faith Ringgold ©1990. Mary Cassatt, The Child's Bath, 1893. Oil on canvas, 39 1/2" x 26" (100.3 x 66.1 cm). The Art Institute of Chicago. Mogolion (Casas Grandes style), Macaw Bowl, Tardio Period, 1300-1350. Earthenware with polychrome slip painting, 5 1/4" x 8" x 6 1/4" (13.3 x 20.3 x 15.9 cm). Museum of Fine Arts, Houston (Gift of Miss Ima Hogg). xiii: Frida Kahlo, Portrait of Virginia, 1929. Oil on masonite, 30" x 23 1/2" (76.5 x 59.5 cm). Copyright Banco de Mexico Trust. Photo Credit: Schalkwijk /Art Resource, NY. xiv: Diego Rivera, Children at

Lunch, 1935. Private collection, ©Banco de Mexico Trust. Private collection. Art Resource, NY. Sofonisba Anguissola, A Game of Chess, Involving the Painter's Three Sisters and a Servant, 1555. Oil on canvas, 28 1/4" x 38 1/4" (72 x 97 cm). Muzeum Narodowe, Poznan, Poland. Photo Erich Lessing/Art Resource, NY. India, The Taj Mahal at Agra, Uttar Pradesh, built by Shah Jahan in 1632–43, with European sightseers on the terrace. Watercolor painting with angels pouring gold from the clouds. Persian text and floral decoration in the border. British Library, London. Photo: Erich Lessing/Art Resource, NY. xv: Ancient Egypt, The Watering of Plants in a Garden, 19th Dynasty, 1300–1200 BCE. Painting from the tomb of the sculptor Ipui (no. 217), in Deir el-Medina (Thebes-West). Photo: Bildarchiv Preussischer Kulturbesitz/Art Resource, NY. Arthur Lismer, A September Gale, Georgian Bay, 1920. Oil on canvas, 20 1/4" x 24" (51.5 x 61 cm). National Gallery of Canada, Ottawa. China, wall hanging. Private collection. Francisco José de Goya y Lucientes, Portrait of General José Manuel Romero, 1810. Oil on canvas, 41 1/2" x 34 1/2" (105.41 x 87.63 cm). The Art Institute of Chicago. xvi: Leonardo da Vinci, Mona Lisa (La Gioconda), 1503–06. Oil on wood, 30 1/4" x 20 7/8" (77 x 53 cm). Photo: R. G. Ojeda. Louvre, Paris, Reunion des Musées Nationaux/Art Resource, NY. Tom Wesselmann, Still Life #30, © Estate of Tom Wesselmann/Licensed by VAGA, New York, NY, 1963. Assemblage: Oil, enamel, and synthetic polymer paint on composition board with collage of printed advertisements, plastic flowers, refrigerator door, plastic replicas of 7-Up bottles, glazed and framed color reproduction, and stamped metal, 48 1/2" x 66" x 4" (122 x 167.5 x 10 cm). Gift of Philip Johnson. Museum of Modern Art, New York, NY. ©The Museum of Modern Art/Licensed by SCALA/Art Resource, NY. David Hockney, Garrowby Hill, 1998. Oil on canvas, 60" x 76" (152.4 x 193 cm). Museum of Fine Arts, Boston. xvii: Heinrich Campendonk, Landscape, 1917. Oil on canvas, 26 3/8" x 19 1/2" (67 x 49.5 cm). The Art Institute of Chicago. Heinrich Campendonk Art ©2007 ARS, NY/VG Bild-Kunst, Bonn. Reclining Jaguar, 1440–1521. Aztec. Stone, 5" x 11" 5 3/4" (12.7 x 27.9 x 14.6 cm.) Brooklyn Museum. Vincent van Gogh, The Bedroom, 1889. Oil on canvas, 29" x 36 1/4" (73.6 x 92.3 cm). The Art Institute of Chicago. xviii: Vincent van Gogh, Starry Night, 1889. Oil on canvas, 29" x 36 1/4" (73.7 x 92.1 cm). The Museum of Modern Art, New York. ©The Museum of Modern Art/Licensed by SCALA/Art Resource, NY. xix: Paul Klee, Castle and Sun, 1928. Oil on canvas. Private collection, Great Britain. Erich Lessing/Art Resource, NY. Paul Klee Art ©2007 ARS, NY/VG Bild-Kunst, Bonn. Frank Gehry, Hotel Marques de Riscal Elciego, (Alava) Spain. Photo: www.thomasmayerarchive.com, 2006. xx: Loïs Mailou Jones, Coin de la rue Medard, 1947. Oil on canvas, 18" x 22" (45.7 x 56 cm). The Phillips Collection, Washington, DC.

Unit 1

2: André Derain, Mountains at Collioure, 1905. Oil on canvas, 32" x 39 1/2" (81.3 x 100.3 cm). John Hay Whitney Collection, ©2007 Board of Trustees, National Gallery of Art, Washington, DC. Andre Derain Art ©2007 ARS, NY/ADAGP, Paris. 3: André Derain, London Bridge, ©ARS, NY, 1906. Oil on canvas, 26" x 39" (66 x 99 cm). Museum of Modern Art, New York. ©The Museum of Modern Art/Licensed by SCALA/Art Resource, NY; Photograph of Andre Dérain, ©Albert Harlingue/Roger-Viollet/The Image Works. Andre Derain Art ©2007 ARS, NY/ADAGP, Paris. 4: (A) Ahmad Ma'mar Lahori, The Taj Mahal at Agra, 1632. ©Davis Art Images. (B) India, The Taj Mahal at Agra, Uttar Pradesh, built by Shah Jahan in 1632–43, with European sightseers on the terrace. Watercolor painting with angels pouring gold from the clouds. Persian text and floral decoration in the border. British Library, London. Photo: Erich Lessing/Art

Resource, NY. 5: (C) Peter Eisenman and Richard Trott, The Wexner Center for the Arts, Columbus, Ohio. 6: (A) Checkerboard garden at Port Lympne, Kent, England. Photo ©Impact Photos/Pamela Toler. 7: (B) Heinrich Campendonk, Landscape, 1917. Oil on canvas, 26 3/8" x 19 1/2" (67 x 49.5 cm). The Art Institute of Chicago. Heinrich Campendonk Art ©2007 ARS, NY/ VG Bild-Kunst, Bonn. 9: (A) Richard Steele, Autumn Reflection, 2004. Watercolor, 16 1/2" x 24 1/2" (42 x 62 cm). Courtesy of the artist. (C) iStockphoto.com/ Berthold Trenkel. (D) iStockphoto.com, Joey Elbaum. 13: (C) Alexander Calder, Bird Pull Toy, ©ARS, NY, 1951. Brass wire, lead, coffee can, spring. Private collection. Photo: Art Resource, NY. ©2007 Estate of Alexander Calder/ARS, NY. 14: (A) Ralph Goings, Relish, 1994. Oil on canvas, 44" x 64 1/2" (111.76 x 163.83 cm). OK Harris Works of Art, New York, NY. 15: (C) Tom Wesselmann, Still Life #30, © Estate of Tom Wesselmann/Licensed by VAGA, New York, NY, 1963. Assemblage: Oil, enamel, and synthetic polymer paint on composition board with collage of printed advertisements, plastic flowers, refrigerator door, plastic replicas of 7-Up bottles, glazed and framed color reproduction, and stamped metal, 48 1/2" x 66" x 4" (122 x 167.5 x 10 cm). Gift of Philip Johnson. Museum of Modern Art, New York, NY. ©The Museum of Modern Art/Licensed by SCALA/Art Resource, NY. 17: (A) Niki de Saint Phalle, Nikigator, 2001. Photographed at Atlanta Botanical Gardens, 2006, 7" x 25" x 8" (2 x 7.5 x 2.5 cm). ©Niki Charitable Art Foundation. Photo: Justin Larose/©2007 Turner Broadcasting System, Inc., A Time Warner Company. Niki de Saint Phalle Art ©2007 ARS, NY/ADAGP, Paris. (C) iStockphoto.com/Nuna Silva. (D) iStockphoto. com/Kennith Ponder. 20: (A) iStockphoto.com/Andrea Sturm. (B) iStockphoto.com/Flavia Bottazzini. 21: (C) iStockphoto.com/Mike Bentley. 22: (A) Albrecht Dürer, Rhinoceros, 1515. Woodcut on paper, 9 7/8" x 12" (24.8 x 30.4 cm). The Art Institute of Chicago. 23: (B) Saul Steinberg, Hen, ©ARS/NY, 1945. Pen and brush and India ink on paper, 14 1/2" x 23 1/8" (36.8 x 58.7 cm). The Museum of Modern Art, New York, NY ©The Saul Steinburg Foundation/ARS, NY ©The Museum of Modern Art/Licensed by Scala/Art Resource, NY. (B) iStockphoto.com/Constance McGuire. 25: (A) Natalie Surving, Kissing Gourami, 2006. Clay tile, 6" x 6" (15 x 15 cm). Surving Studios, www.surving.com. (C) iStockphoto.com/Xavi Arnau. (D) iStockphoto. com/Robin Arnold. 28: (A) Ancient Egypt, The Watering of Plants in a Garden, 19th Dynasty, 1300–1200 BCE. Painting from the tomb of the sculptor Ipui (no. 217), in Deir el-Medina (Thebes-West). Photo: Bildarchiv Preussischer Kulturbesitz/Art Resource, NY. 30: (C) Ralph Goings, Relish, 1994. Oil on canvas, 44" x 64 1/2" (111.76 x 163.83 cm). OK Harris Works of Art, New York, NY. 31: (A) Berthe Morisot, Girl in a Boat with Geese, ca. 1889. Oil on canvas, 25 3/4" x 21 1/2" (65.4 x 54.6 cm). Ailsa Mellon Bruce Collection. ©2007 Board of Trustees, National Gallery of Art, Washington, DC.

Unit 2

32: (A) Mary Cassatt, The Child's Bath, 1893. Oil on canvas, 39 1/2" x 26" (100.3 x 66.1 cm). The Art Institute of Chicago. 33: (B) Mary Cassatt, The Boating Party, 1893–94. Oil on canvas, 35 3/8" x 46 1/4" (90 x 117.3 cm). ©2007 Board of Trustees, National Gallery of Art, Washington, DC. Photo of Mary Cassatt, Culver Pictures. 34: (B) iStockphoto.com/Kativ. (C) iStockphoto. com/Rich Koele. 35: (D) Pasquale Wowak–FOTOLIA. (E) iStockphoto.com/Roberto Osborne. 36: (A) Fernando Castillo, Portrait of Ernestina, 1937. Oil on canvas, 23 1/2" x 19 1/2" (59.7 x 49.5 cm). Private Collection. Art Resource, NY. 37: (B) Master of the Legend of the Magdalene, Portrait of Philip the Fair, ca. 1483. Oil on panel, 11 1/2" x 9 1/2" (29 x 24 cm). Philadelphia Museum of Art. Photo: Graydon Wood. (C) Doris

Ulmann, Untitled (girl seated, edge of porch), ca. 1925–1934. Gelatin silver photograph on paper, 8 1/4" x 6 1/4" (21 x 16 cm). ©Davis Art Images. 38: (B) Getty Images. 39: (A) Sofonisba Anguissola, A Game of Chess, Involving the Painter's Three Sisters and a Servant, 1555. Oil on canvas, 28 1/4" x 38 1/4" (72 x 97 cm). Muzeum Narodow, Poznan, Poland. Photo Erich Lessing/Art Resource, NY. (C) iStockphoto.com/Ana Abejon. (D) iStockphoto.com/Eileen Hart. 42: (A) Winslow Homer, Snap the Whip, 1872. Oil on canvas, 22" x 35 7/8" (56 x 91 cm). Butler Institute of American Art, Youngstown, OH. 43: (B) Susan J. Geissler, Puddle Jumper, 2005. Sculpture. Courtesy of the artist. 44: (A) William Glackens, Washington Square, 1913. Charcoal, pencil, colored pencil, gouache, and watercolor on paper, 29 1/8" x 22 1/8" (74 x 56 cm). The Museum of Modern Art, New York. ©The Museum of Modern Art/Licensed by SCALA/Art Resource, NY. 46: (B) iStockphoto.com/Andrea Gingerich. 47: (A) Willie Birch, Going Home, 1992. Papier-mâché and mixed media. Courtesy of Arthur Roger Gallery, New Orleans and The Ogden Museum of Southern Art, University of New Orleans. (C) Anderson Ross/Blend Images/Getty Images. (D) iStockphoto.com/Oleg Kozlov. 50: (A) Jacob Lawrence, Virginia Interior, 1942. Gouache painting on ivory wove paper, 21 5/8" x 22 1/8" (535 x 560 cm (image); 560 x 584 cm (sheet). The Art Institute of Chicago. ©2007 The Jacob and Gwendolyn Lawrence Foundation/ARS, NY. 51: (B) Vincent van Gogh, The Bedroom, 1889. Oil on canvas, 29" x 36 1/4" (73.6 x 92.3 cm). The Art Institute of Chicago. 52: (A) Charles Bulfinch, Church of Christ, 1816. Lancaster, MA. Photo credit: Steve Dunwell. 54: (B) Getty Images. 55: (C) Frank Stella, Dresden Project, View 3, ©ARS, NY 1992. Stainless steel and bronze model, 10" x 60" x 41" (25.4 x 152.4 x 104.1 cm). Photo: Steven Sloman.Art Resource, NY. ©2007 Frank Stella/ARS, NY. (C) iStockphoto.com/Gene Krebs. (D) iStockphoto.com/Robbie Rogers. 58: (A) Leonardo da Vinci, Mona Lisa (La Gioconda), 1503–06. Oil on wood, 30 1/4" x 20 7/8" (77 x 53 cm). Photo: R. G. Ojeda. Louvre, Paris, Reunion des Musées Nationaux/Art Resource, NY. 59: (B) Hashiguchi Goyo, Woman Combing Her Hair, 1928. Color woodblock print, 17 5/8" x 13 3/4" (44.8 x 34.9 cm). The Art Institute of Chicago. (C) Dale Kennington, Barber Shop, ca. 1995. Oil on canvas, 40 1/4" x 50" (102 x 127 cm). Butler Institute of American Art, Youngstown, OH. 60: (B) Frank Stella, Dresden Project, View 3, ©ARS, NY 1992. Stainless steel and bronze model, 10" x 60" x 41" (25.4 x 152.4 x 104.1 cm). Photo: Steven Sloman.Art Resource, NY. ©2007 Frank Stella/ARS, NY. (C) Fernando Castillo, Portrait of Ernestina, 1937. Oil on canvas, 23 1/2" x 19 1/2" (59.7 x 49.5 cm). Private Collection. Art Resource, NY. 61: Sarah McEneaney, Callowhill Neighborhood, 2002. Egg tempera on panel, 16" x 20" (40.64 x 50.8 cm). Tibor De Nagy Gallery, NYC.

Unit 3
62: (A) Maurice Sendak. Rosenbach Museum and Library. From Where the Wild Things Are, 1963. Pen and ink illustration. ©1963 HarperCollins. 63: (B) Maurice Sendak. Rosenbach Museum and Library. From Brundibar, 2003. Pen and ink illustration. ©2003 HarperCollins. Photo of Maurice Sendak, AP Images. 65: (B) Paul Klee, Castle and Sun, 1928. Oil on canvas. Private collection, Great Britain. Erich Lessing/Art Resource, NY. Paul Klee Art ©2007 ARS, NY/VG Bild-Kunst, Bonn. 66: (A) Wassily Kandinsky, Improvisation 31 (Sea Battle), 1913. Oil on canvas, 55 3/8" x 47 1/8" (140.7 x 119.7 cm). ©2007 Board of Trustees, National Gallery of Art, Washington, DC. Wassily Kandinsky Art ©2007 ARS, NY/ADAGP, Paris. 67: (B) Helen Frankenthaler, Spring Bank, 1974. Oil on canvas. Musée National d'Art Moderne, Centre Georges Pompidou, Paris. Photo: Bridgeman-Giraudon/Art Resource, NY.

68: (B) Victoria Snowber/Getty Images. 69: (A) Trenton Doyle Hancock, Esther, 2002. Graphite and acrylic on paper, 29 x 27 cm. James Cohan Gallery, New York. (C) iStockphoto.com/Alison Cornford-Matheson. (D) iStockphoto.com/Pamela Moore. 72: (A) Maurice Prendergast, Pincian Hill, Rome, 1898. Watercolor over graphite pencil under drawing on thick, medium-textured, off-white watercolor paper. Phillips Collection, Washington, DC. 73: (B) Milton Avery, Harbor at Night, 1932. Oil on canvas, 32" x 48" (81.28 x 121.92 cm). The Phillips Collection, Washington, DC. ©2007 The Milton Avery Trust/ARS, NY. 74: (A) John Steuart Curry, Tornado Over Kansas, 1929. Oil on canvas. Collection of the Muskegon Museum of Art, Michigan. 76: (B) Image Source/Getty Images. 77: (A) Carmen Lomas Garza, Cakewalk, 1987. Acrylic on canvas, 36" x 48" (91.44 x 121.92 cm). Courtesy of the artist. (C) iStockphoto.com/Valarie Loiseleux. (D) Getty Images. 80: (A) Jan Brett, from Jan Brett's The Mitten, 1989 Watercolor illustration. ©1989 Penguin Young Readers Group, NY. 81: (B) Jan Brett, from Jan Brett's The Mitten, 1989. Watercolor illustration. ©1989 Penguin Young Readers Group, NY. 82: (A) Jim McNeill, Hungry Dino, 2006. Digital illustration. 83: (B) Jim McNeill, Jumper, 2006. Digital illustration. 84: (B) iStockphoto.com/Sean Locke. 85: (A) Ragmala, India, ca. 1680. Opaque watercolor and gold leaf on paper, 14 3/4" x 8 1/2" (37.2 x 21.7 cm). Brooklyn Museum, NY. (C) iStockphoto.com/Sean Locke. (D) iStockphoto.com/Sean Locke. 88: (A) Greek, Attic black figure amphora, Ajax and Achilles playing dice, 550–501 BCE. Museo Nazionale di Villa Giulia, Rome, Italy. Nimatallah/Art Resource, NY. 89: (B) Story-telling scroll. 1900s. Private collection, Prague, Czech Republic. Werner Forman/Art Resource, NY. iStockphoto.com/Martynas Jochnevicius. 90: (A) Trenton Doyle Hancock, Esther, 2002. Graphite and acrylic on paper, 29 x 27 cm. James Cohan Gallery, New York. (B) Carmen Lomas Garza, Cakewalk, 1987. Acrylic on canvas, 36" x 48" (91.44 x 121.92 cm). Courtesy of the artist. (C) Image from Cuckoo, A Mexican Folktale-Cucu, Un Cuento Folklorico Mexicano, ©1997 by Lois Ehlert, reprinted by permission of Harcourt, Inc.

Unit 4
92: (A) Henri Rousseau, The Banks of the Bièvre near Bicêtre. Oil on canvas. 21 1/2" x 18" (54.6 x 45.7 cm). The Metropolitan Museum of Art. 93: (B) Henri Rousseau, Tropical Forest with Monkeys, 1910. Oil on canvas, 51" x 64" (129.5 x 162.5 cm). John Hay Whitney Collection. ©2007 Board of Trustees, National Gallery of Art, Washington, DC. Pablo Picasso, (1881–1973) ©ARS, NY. Portrait of Henri (Le Douanier) Rousseau, 1910. Réunion des Musées Nationaux/Art Resource, NY. 94: (A) Evan Summer, Salvazano imperalis, 2005. Graphite and pastel drawing. Courtesy of the artist. (B) Suzanne Duranceau, Leaf Insect, 2007. Pencil and acrylic painting. ©2007. Suzanne Duranceau. 95: (C) Suzanne Duranceau, Beetle, 2007. Pencil and acrylic painting. ©2007. Suzanne Duranceau. 96: (A) Merian, Maria Sibylla, Orange-flowered plant and the life cycle of a moth and beetle. From an album of 91 drawings entitled Merian's Drawings of Surinam Insects & Amphibians with Examples of Pupa, Chrysalis and Caterpillars, 1705. Watercolor, touched with body color, and with pen and gray ink, on vellum. British Museum/Art Resource, NY. 97: (B) Unknown, Panel from a Bed Curtain, 1700s. Linen plain weave with silk satin stitch, darning stitch, stem stitch, straight stitch, and eyelet stitch embroidery, 30 3/8" x 41 1/2" (77.153 x 105.41 cm). Allentown Art Museum, Allentown, PA. 98: (B) iStockphoto.com/Sevgiy Shcherbakov. 99: (A) Andy Warhol, San Francisco Silverspot, Endangered Species Series, 1983. Synthetic polymer paint and silkscreen ink on canvas, 60" x 60" (152.4 x 152.4 cm).

The Andy Warhol Foundation, Inc./Art Resource, NY. (C) Willie Schmitz. (D) iStockphoto.com/geopaul.102: (A) Tom Thomson, Northern River, 1915. Oil on canvas, 45 1/4" x 40 1/4" (115.1 x 102 cm). National Gallery of Canada, Ottawa. 103: (B) Arthur Lismer, A September Gale, Georgian Bay, 1920. Oil on canvas, 20 1/4" x 24" (51.5 x 61 cm). National Gallery of Canada, Ottawa. 104: (A) David Hockney, Garrowby Hill, 1998. Oil on canvas, 60" x 76" (152.4 x 193 cm). Museum of Fine Arts, Boston. 105: (B) Franz Morgner, Field-path, 1912. Oil painting. Kunstsammlung Bochum, Bochum, Germany. Erich Lessing/Art Resource, NY. 106: (B) iStockphoto.com/Craig Barhorst. 107: (A) Henri Rousseau, Carnival Evening, 1886. Oil on canvas, 46 1/8" x 35 3/8" (117 x 90 cm). Philadelphia Museum of Art. (C) iStockphoto.com/Lara Hogan. (D) iStockphoto.com/Narelle Robson-Petch. 110: (A and B) Walter Anderson, linoleum block prints from An Alphabet, 1984, 1992. The Family of Walter Anderson. 112: (B) Isoda Koryusai, Japanese, fl. ca. 1764–1788, The White Falcon (detail), Edo period, 1780. Color woodblock print, ishizuri-e, 35" x 11 5/8" (88.8 x 29.5 cm.), Clarence Buckingham Collection, The Art Institute of Chicago. Photography ©The Art Institute of Chicago. 113: (D) Luis Benedit, Pullet, 1963. Oil and enamel on canvas, 31 1/2" x 23 7/10" (80 x 60.2 cm). ©The Museum of Modern Art/Licensed by SCALA/Art Resource, NY. 114: (B) iStockphoto.com/Daniel Cooper. 115: (A) Reclining Jaguar, 1440–1521. Aztec. Stone, 5" x 11" 5 3/4" (12.7 x 27.9 x 14.6 cm.) Brooklyn Museum. (C) iStockphoto.com/Clint Scholz. (D) iStockphoto.com/Markus Seidel. 118: (A) Prehistoric, Herd of Horses, ca. 15,000 BCE. Serigraph, transcription of prehistoric cave wall painting. Lascaux Caves, Perigord, Dordogne, France. Art Resource, NY. 119: (B) Bill Reid, Phyllidula–The Shape of Frogs to Come, 1985. Red cedar sculpture. Vancouver Art Gallery Acquisition Fund. (C) Courtesy of Pearl Fryar's Topiary Garden. 120: (A) Suzanne Duranceau, Leaf Insect, 2007. Pencil and acrylic painting. ©2007. Suzanne Duranceau. (B) Henri Rousseau, Tropical Forest with Monkeys, 1910. Oil on canvas, 51" x 64" (129.5 x 162.5 cm). John Hay Whitney Collection. ©2007 Board of Trustees, National Gallery of Art, Washington, DC. Pablo Picasso, (1881–1973) ©ARS, NY. Portrait of Henri (Le Douanier) Rousseau, 1910. Réunion des Musées Nationaux/Art Resource, NY. 121: (A) Zeny Fuentes, Red Cat, ca. 2006. Painted wood carving, approx. 24" (60.96 cm) high. Courtesy of the artist.

Unit 5
122: (A) William H. Johnson, Children Playing London Bridge, ca. 1942. Watercolor on paper, 12" x 10 1/2" (30.48 x 26.67 cm). David C. Driskell Collection. 123: (B) William H. Johnson, Going to Church, ca. 1940–41. Oil on burlap, 38 1/8" x 45 1/2" (96.8 x 115.6 cm). Smithsonian American Art Museum, Washington, DC/Art Resource, NY. Photo of William H. Johnson, Steve Turner Gallery, Los Angeles. 124: (A) Photo of Worcester, MA. Unknown, photograph ca. 1903–1904. 125: (B) Shanghai office buildings at night. ©2005 Corbis. 126: (A) Nassau Hall, stamp, 1956. ©United States Postal Service. 127: (B) West Point stamp, 1937. National Postal Museum, Smithsonian Institution. (B) Joern Utzon, Sydney Opera House, 1959–72. Sydney, Australia. ©Paul A. Souders/Corbis. 129: (A) Thomas U. Walter, United States Capitol, Washington, DC, 1851–1863. Photo ©Davis Art Images. (C) iStockphoto.com/Victoria Wren. (D) iStockphoto.com/Joe Sohm/Getty Images. 132: (A) China, wall hanging. Private collection. 133: (B) Doris Lee, Thanksgiving, ca. 1935. Oil on canvas, 28 1/2" x 40 1/8" (71.3 x 101.8 cm). The Art Institute of Chicago. 134: (A) David Bates, Feeding Dogs, 1986. Oil on canvas. Collection of Phoenix Art Museum. (B) Gini Lawson, Ellie, 2005. Oil on canvas, 18" x 24" (45.72 x 60.96 cm). Courtesy of the artist. 135: (C) William Morris Hunt,

Girl with Cat, 1856. Oil on canvas, 42 1/8" x 33 3/8" (107 x 84.77 cm). Museum of Fine Arts, Boston. 136: (B) iStockphoto.com/Harry Lines. 137: (A) Faith Ringgold, Echoes of Harlem. Acrylic on canvas, dyed, painted, and pieced fabric, 96" x 84". Faith Ringgold, ©1980. (C) iStockphoto.com/Richard Goerg. (D) iStockphoto.com/Vaide Seskauskiene. 140: (A) Wayne Thiebaud, Boston Cremes, from the portfolio Seven Still Lifes and a Silver Landscape, 1970, published 1971. Linoleum cut printed in color on paper, 13 7/8" x 20 1/2" (35 x 52 cm). ©The Museum of Modern Art/Licensed by SCALA/Art Resource, NY. 141: (B) Courtesy Delicious Desserts, Falmouth, MA. 142: (A) Young Mardi Gras Indian, New Orleans, Louisiana, U.S.A., 1989. Syndey Byrd. 143: (B) iStockphoto.com/Mercedes Soledad Manrique. 145: (A) Jaguar mask, Mexico. Private Collection. (C) iStockphoto.com/Jeryl Tan. (D) iStockphoto.com/Heidi Tuller. (E) iStockphoto.com/Graeme Purdy. 148: (A) Godfried Schalcken, Boys Flying Kites, ca. 1670. Oil on oak pane, 17 1/2" x 13 1/2" (44.5 x 34.3 cm). Upton House, Bearsted Collection, Banbury, Oxfordshire, Great Britain. Photo: National Trust/Art Resource, NY. 149: (B) Diego Rivera, La Piñata, 1953. Mural. Hospital Infantil "Francisco Gomez" Mexico City, D. F., Mexico. ©Banco de Mexico Trust. Photo Credit: Schalkwijk/Art Resource, NY. (C) Courtesy of Delicious Desserts, Falmouth, MA. 150: (B) Courtesy Delicious Desserts, Falmouth, MA. (C) iStockphoto.com/Richard Goerg. 151: (A) Carmen Lomas Garza, Cumpleaños de Lala y Tudi (Lala and Tudi's birthday party), 1989. Oil on canvas, 36" x 48" (91.44 x 121.92 cm). Courtesy of the artist.

Unit 6
152: (A) Frank Gehry, Hotel Marques de Riscal Elciego, (Alava) Spain. Photo: www.thomasmayerarchive.com, 2006. 153: (B) Frank Gehry, Walt Disney Concert Hall, 2003. ©Rufus F. Folkks/CORBIS. Photo of Frank Gehry, AP Images. 154: (A) Claude Monet, Sandvika, Norway, 1895. Oil on canvas, 28 7/8" x 36 3/4" (73.4 x 92.5 cm). The Art Institute of Chicago. 155: (B) Hale Woodruff, Twilight, 1926. Oil on pressed paper board, 28" x 32" (71.1 x 81.3 cm). The Art Institute of Chicago. 156: (A) Marjorie Phillips, Golf at St. Cloud, ca. 1924. Oil on canvas board, 9" x 12" (22.86 x 30.48 cm). The Phillips Collection, Washington DC. 157: (B) Marjorie Phillips, Night Baseball, 1951. Oil on canvas, 24 1/4" x 36" (61.595 x 91.44 cm). The Phillips Collection, Washington, DC. 158: (B) ©Tomislav Stajduhar-Fotolia. 159: (A) Maria Sybilla Merian, Life Cycles of Two Moths. From an album of 91 drawings entitled Merian's Drawings of Surinam Insects & Amphibians with Examples of Pupa, Chrysalis and Caterpillars, 1705. Watercolor, touched with body color, heightened with white, on vellum. British Museum, London. ©British Museum/Art Resource, NY. (C) ©Hazel Proudlove-Fotolia. (D) iStockphoto.com/Brendon De Suza. 162: (A) Louise Elizabeth Vigée-LeBrun, Marie-Antoinette, Queen of France, with a Rose (1755–1793). 1783. Oil on canvas, 131 x 87 cm. Inv.: 3893. Chateaux de Versailles et de Trianon, Versailles, France. Photo Credit: Réunion des Musées Nationaux/Art Resource, NY 163: (B) Lucas Cranach (The Elder), Portrait of Hedwig, Margravine of Brandenburg-Ansbach, 1529. Oil on panel, 23 3/16" x 15 7/8" (58.9 x 40.32 cm). The Art Institute of Chicago. (C) Francisco José de Goya y Lucientes, Portrait of General José Manuel Romero, 1810. Oil on canvas, 41 1/2" x 34 1/2" (105.41 x 87.63 cm). The Art Institute of Chicago. 164: (A) Antonio Berni, New Chicago Athletic Club, 1937. Oil on canvas, 72 7/8" x 118 1/8" (185 x 300 cm). Inter-American Fund. The Museum of Modern Art, New York, NY, U.S.A. Digital Image ©The Museum of Modern Art/Licensed by SCALA/Art Resource, NY. 165: (B) Winslow Homer, Croquet Scene, 1866. Oil on canvas, unframed: 15 7/8" x 26 1/8" (40.3 x 66.2 cm) framed: 24 3/4" x 34 3/4" (62.9 x 88.3 cm).

The Art Institute of Chicago. 166: (B) C. Pascal Le Segretain/Gisele. 167: (A) Private collection. (C) C. Pascal Le Segretain/Yanik Chauvin. (D) C. Pascal Le Segretain/Pathathai Chungyan. 170: (A) Toshiyuki Kita, Wink Lounge Chair (model 111.01), 1980. Polyurethane foam, steel, and Dacron, Overall (upright): 40 5/8" x 33" x 31 5/8" (103.2 x 83.8 x 80.3 cm) seat h. 14 3/4" (37.5 cm); (reclining): 24 3/8" x 33" x 75 3/4" (61.9 x 83.8 x 192.4 cm). Manufactured by Cassina, S.p.A., Milan. Gift of Atelier International Ltd. (SC21.1981. a-g) The Museum of Modern Art, New York, NY, U.S.A. Photo credit : Digital Image © The Museum of Modern Art/Licensed by SCALA/Art Resource, NY. 171: (B) Frank Gehry, Easy Edges Side Chair, 1972. Laminated corrugated cardboard, fiberboard, 33 1/2" x 16 5/8" x 24 1/8" (85.1 x 42.2 x 61.3 cm). Museum of Modern Art, New York, NY, U.S.A. Digital Image ©The Museum of Modern Art/Licensed by SCALA/Art Resource, NY. (C) Gerrit Rietveld, Zig-Zag Chair, ©ARS, NY. 1934. Wood. Manufactured by G.A. Van de Groenekan, Amsterdam, The Netherlands, 29" x 14 7/8" x 16", seat height 17" (73.66 x 37.78 x 40.64 cm, seat height 43.18 cm) The Museum of Modern Art, New York, NY, U.S.A. Digital Image ©The Museum of Modern Art/Licensed by SCALA/Art Resource, NY. 172: (A) Micro Compact Car Smart GmbH, company design. (German and French, founded 1994). Smart Car ("Smart & Pulse" Coupé). 1998. Steel frame and thermoplastic body panels, 61" x 59 3/8" x 8' 2 3/8" (154.9 x 150.8 x 249.9 cm). Manufactured by Micro Compact Car Smart GmbH, Renningen, Germany, and Hambach, France. Gift of the manufacturer, a company of the DaimlerChrysler Group. Museum of Modern Art, New York, NY, U.S.A. Digital Image ©The Museum of Modern Art/Licensed by SCALA/Art Resource, NY. 173: (B) Panamarenko, Flying Object (Rocket), 1969. Balsa wood, cardboard, plastic, fabric, aluminum, steel, and synthetic polymer paint, 107 1/8" x 136 1/4" x 98" (272 x 346 x 249 cm). The Museum of Modern Art, New York, NY, U.S.A. Digital Image ©The Museum of Modern Art/Licensed by SCALA/Art Resource, NY. 174: (B) C. Pascal Le Segretain/Photoservice. 175: (A) Sony Corporation and Hajime Sorayama, Aibo Entertainment Robot (ERS-110), 1999. Various materials, 10 1/2" x 6" x 16 1/4" (26.7 x 15.2 x 41.3 cm). Manufactured by Sony Corporation, Japan. Gift of the manufacturer. The Museum of Modern Art, New York, NY, U.S.A. Digital Image ©The Museum of Modern Art/Licensed by SCALA/Art Resource, NY. (C) C. Pascal Le Segretain/Michael Knight. (D) C. Pascal Le Segretain/David Luscombe. 178: (A) Jack Mongillo, Whirligig Man (Man on a Bicycle), ca. 1940. Wood. American folk art, from Salamanca, NY. Ricco-Maresca Gallery, New York, NY, U.S.A. Photo credit: Ricco-Maresca Gallery/Art Resource. 179: (B) Alexander Calder, The Four Elements, 1961. Iron. Moderna Museet, Stockholm, Sweden. ©Alexander Calder/BUS 2006. ©2007 Estate of Alexander Calder/ARS, NY. 180: (A) Gerrit Rietveld, Zig-Zag Chair, ©ARS, NY. 1934. Wood. Manufactured by G.A. Van de Groenekan, Amsterdam, The Netherlands, 29" x 14 7/8" x 16", seat height 17" (73.66 x 37.78 x 40.64 cm, seat height 43.18 cm) The Museum of Modern Art, New York, NY, U.S.A. Digital Image ©The Museum of Modern Art/Licensed by SCALA/Art Resource, NY. (B) Frank Gehry, Hotel Marques de Riscal Elciego, (Alava) Spain. Photo: www.thomasmayerarchive.com, 2006. (C) Claude Monet, Sandvika, Norway, 1895. Oil on canvas, 28 7/8" x 36 3/4" (73.4 x 92.5 cm). The Art Institute of Chicago. 181: Cai Guo Qiang, Transient Rainbow, 2002. 1000 three-inch multicolor peonies fitted with computer chips, 300 x 600', duration 15 seconds. Commissioned by The Museum of Modern Art, New York, NY, U.S.A. Photo by Hiro Ihara, Courtesy of the artist.

186: Margaret Burroughs, The Folk Singer—Big Bill, 1996. Linoleum cut, 17 3/8" x 21 1/8" (44.13 x 53.66 cm).

Mary and Leigh Block Museum of Art, Northwestern University, Evanston, IL. Gift of Margaret Burroughs. 186: Martin Johnson Heade, Giant Magnolias on a Blue Velvet Cloth, ca. 1890. Oil on canvas, 15 1/8" x 24 1/4" (38.4 x 61.5 cm). Image ©2007 Board of Trustees, National Gallery of Art, Washington, DC (Gift of the Circle of the National Gallery of Art in Commemoration of its 10th Anniversary). 188: William H. Johnson, Ferry Boat Trip, ca.1943–1944. Oil on paperboard. 33 3/4" x 28 1/2". (85.7 x 72.4 cm). Smithsonian American Art Museum, Washington, DC. Smithsonian American Art Museum, Washington, DC/ Art Resource, NY. 189: Paul Klee, Castle and Sun, 1928. Oil on canvas. Private collection, Great Britain. Erich Lessing/Art Resource, NY. Paul Klee Art ©2007 ARS, NY/VG Bild-Kunst, Bonn. Frank Gehry, Walt Disney Concert Hall, 2003. ©Rufus F. Folkks/CORBIS. 191: Thomas U. Walter, United States Capitol, Washington, DC, 1851–1863. Photo ©Davis Art Images. 192: Getty Images. Carmen Lomas Garza, Cumpleaños de Lala y Tudi (Lala and Tudi's birthday party), 1989. Oil on canvas, 36" x 48" (91.44 x 121.92 cm). Courtesy of the artist. 195: iStockphoto.com/Harry Lines. Bill Reid, Phyllidula–The Shape of Frogs to Come, 1985. Red cedar sculpture. Vancouver Art Gallery Acquisition Fund. 196: iStockphoto.com/Craig Barhorst. 197: Evan Summer, Salvazano imperalis, 2005. Graphite and pastel drawing. Courtesy of the artist. Stockphoto.com/Andrea Sturm. Antonio Berni, New Chicago Athletic Club, 1937. Oil on canvas, 72 7/8" x 118 1/8" (185 x 300 cm). Inter-American Fund. The Museum of Modern Art, New York, NY, U.S.A. Digital Image ©The Museum of Modern Art/Licensed by SCALA/ Art Resource, NY. Micro Compact Car Smart GmbH, company design. (German and French, founded 1994). Smart Car ("Smart & Pulse" Coupé). 1998. Steel frame and thermoplastic body panels, 61" x 59 3/8" x 8' 2 3/8" (154.9 x 150.8 x 249.9 cm). Manufactured by Micro Compact Car Smart GmbH, Renningen, Germany, and Hambach, France. Gift of the manufacturer, a company of the DaimlerChrysler Group. Museum of Modern Art, New York, NY, U.S.A. Digital Image ©The Museum of Modern Art/Licensed by SCALA/Art Resource, NY.

Index

Studio Explorations

Studio Times

Acknowledgments

Program Contributors

Marge Banks,
Olathe District Schools,
Olathe, Kansas

Susan Bivona,
Mount Prospect School,
Basking Ridge, New Jersey

June A. Carey,
Big Cross Street and
Kensington Road Schools,
Glens Falls, New York

Jana J. DeSimone,
Holliman Elementary School,
Warwick, Rhode Island

Laura Felleman Fattal,
Plainfield Public Schools,
Plainfield, New Jersey

Mary Feranda,
Clyde Cox Elementary School,
Las Vegas, Nevada

Bonnie Halvorson,
Columbus Elementary School,
Columbus, Wisconsin

Patricia Hancock,
Fairfield, Iowa

Joseph E. Haviland,
Temple University,
Philadelphia, Pennsylvania

Joan M. Markovich,
Sporting Hill Elementary School,
Mechanicsburg, Pennsylvania

Mary Morrison, Betty O'Regan,
Mark Rudinoff, Nina Silverman,
Jonathan Twersky,
Sanford School,
Hockessin, Delaware

Anna Naiman,
Plains Elementary,
South Hadley, Massachusetts

Miranda Nelken,
Thatcher Brook Primary School,
Waterbury, Vermont

Jennifer Bellows Nesson,
Revere, Massachusetts

Barbara Downing Owen,
Tenacre Country Day School,
Wellesley, Massachusetts

Lisa Pilvelis,
Alice F. Palmer Elementary,
Windsor, NY.

Annie Silverman,
Somerville, Massachusetts

Barbara Silverstein,
Assumption School and Morris
School District Community School,
Morristown, New Jersey

Colleen Steblein,
Bay Colony Elementary School,
Dickinson, Texas

Michelle Surrena,
Fishcreek Elementary School,
Stow, Ohio

Nan Williams,
Winter Park, Florida

Anne Young,
Number Six School,
Merrick, New York

Reviewers

Catherine M. Best
Art Teacher
St. Mary's Elementary School
St. John's, Newfoundland

Lillian Bussey
Art Teacher
Mount Pearl Secondary School
Mount Pearl, Newfoundland

Alexandra Coffee
Art Teacher
Claremont Math and Science
Academy
Chicago, Illinois

Ann Erickson
Leis Instructional Center
Falls Church, Virginia

Mary D. Kehoe
Retired Art Teacher
Detroit Public Schools
Detroit, Michigan

Emma Lea Meyton
Art Education Consultant
Austin, Texas

Robin McDaniel
Art Teacher
Bates Academy,
Detroit Public Schools
Detroit, Michigan

Margaret Ryall
Educational Consultant
St. John's, Newfoundland

Project Staff

President and Publisher
Wyatt Wade

Managing Editor
David Coen

Editor
Reba Libby

Consulting Editor
Claire Mowbray Golding

Reading and Language Arts Specialist
Barbara Place

Design
WGBH Design:
Tong-Mei Chan
Julie DiAngelis
Tyler Kemp-Benedict
Chrissy Kurpeski
Jonathan Rissmeyer
Douglass Scott

Production
Thompson Steele, Inc.

Editorial Assistants
Photo Acquisitions
Annette Cinelli
Mary Nicholson

Illustrator
Susan Christy-Pallo

Photography
Tom Fiorelli

Manufacturing
Georgiana Rock